Simplifying complex scenes in watercolor

by Malcolm Beattie

international
artist

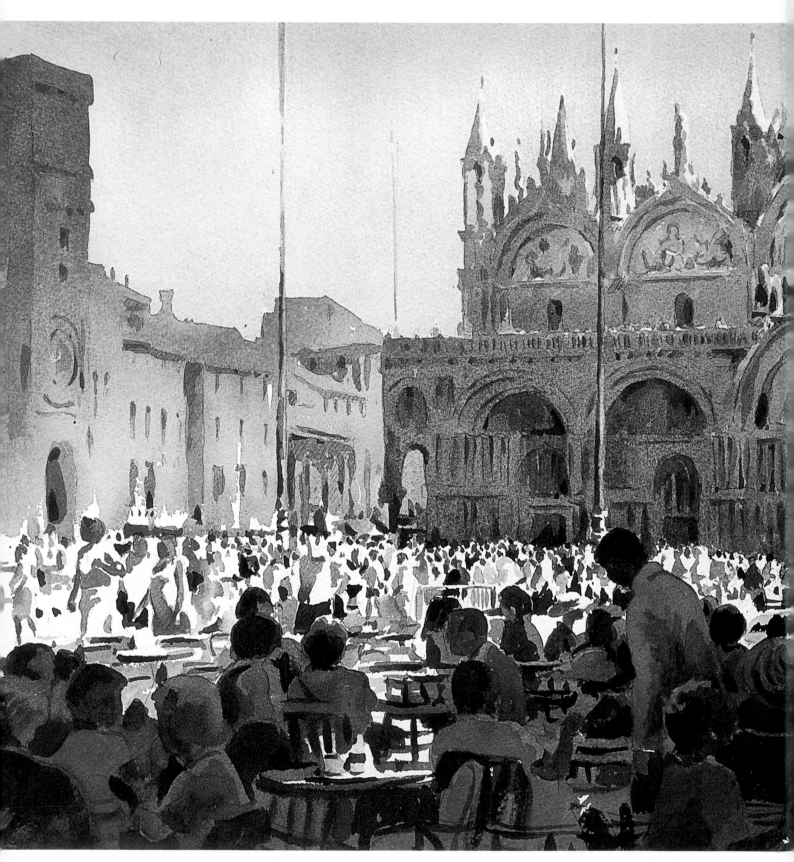

Piazza San Marco from Café Florian, Venice, 14 x 21" (35 x 53cm)

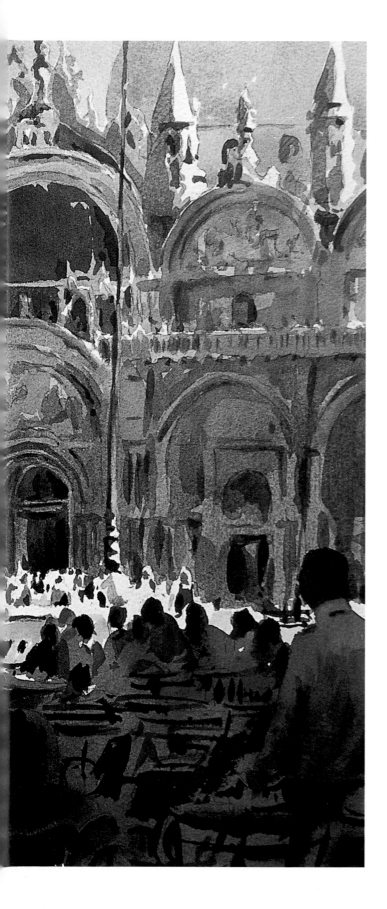

Simplifying complex scenes in watercolor

by Malcolm Beattie

international
artist

International Artist Publishing, Inc
2775 Old Highway 40
P.O. Box 1450
Verdi, Nevada 89439
Website: www.international-artist.com

Edited by Terri Dodd
Designed by Vincent Miller
Typeset by Ilse Holloway and Jan Baxter
Editorial Assistant Dianne Miller

 ISBN 1-929834-24-1

Printed in Hong Kong
First printed in hardcover 2003
07 06 05 04 03 6 5 4 3 2 1

Distributed to the trade and art markets
in North America by:
North Light Books,
an imprint of F&W Publications, Inc
4700 East Galbraith Road
Cincinnati, OH 45236
(800) 289-0963

Acknowledgments

I wish to acknowledge the enormous support of my wife
Dorothy. I thank her for her patience when I asked her the
same question sixty times; her encouragement when I was
overwhelmed by the task ahead; her critical eye when I got
too close to what I was doing, and last, but by no means
least, her lightning word processing skills.

 I would also like to thank Peter Tutera for his boundless
enthusiasm; Robert Lean of Shot, Framed and Hung, for his
generous advice, patience and assistance with the photography
and, of course, all my long-suffering students for their interest
and their willingness to be the guinea pigs for most of the
demonstrations in this book.

 Finally, I wish to thank Vincent Miller and Terri Dodd for their
faith in my ability to communicate my watercolor vision to you.

Dedication

I wish to dedicate this book to Dorothy, my children Mark and
Robyn, and to the memory of Graham Moore.

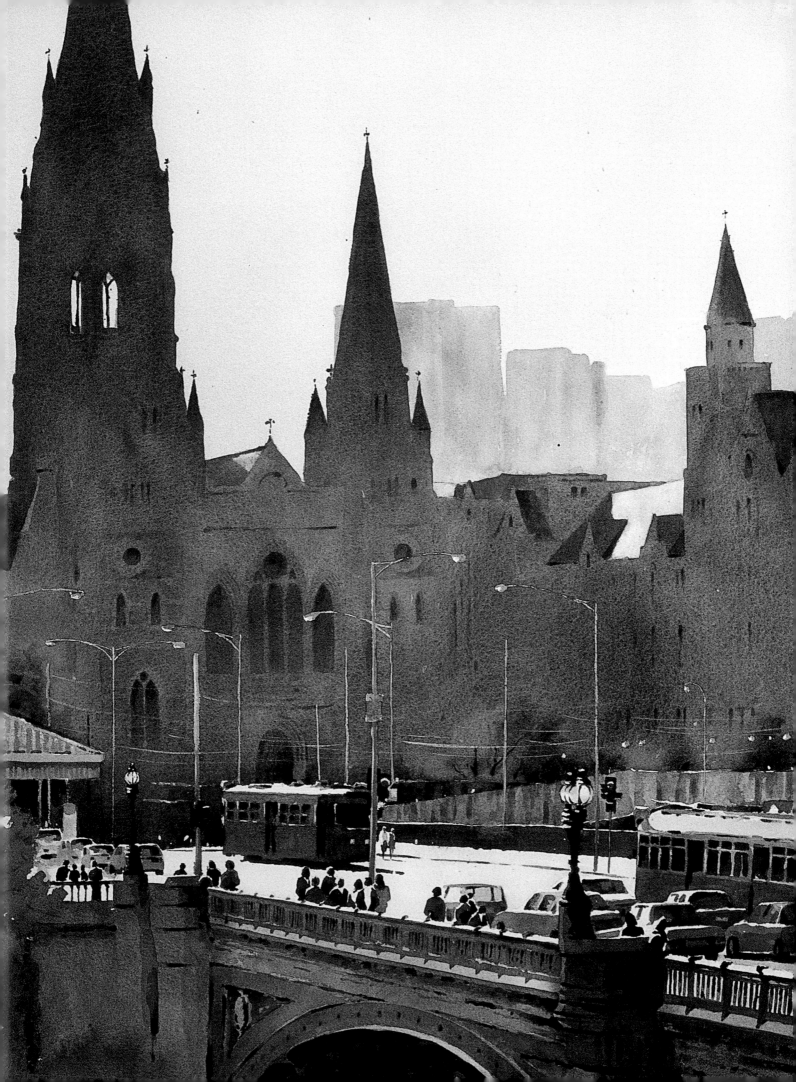

Contents

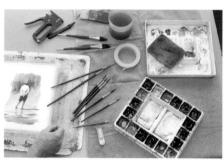
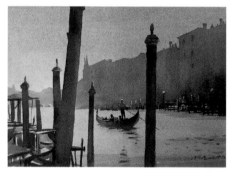

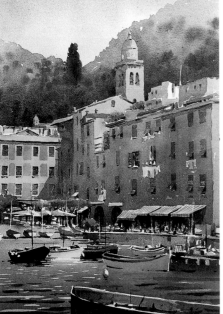

Introduction

Let me explain how I will use the Nag Factor to reinforce the basic principles that are so often neglected because the newcomer just wants to start painting.

This book is a practical, hands-on guide to watercolor. I have tried to strip away the mystery and "secrets" and present a no-fuss, logical approach.

Most of the exercises and paintings included are my class demonstration paintings. I show them to you "warts and all". They are an honest attempt to take you through the watercolor process with no frills, no gimmicks, no tricks, and they were painted in front of an audience of students in a limited time. Of course, there are gallery quality studio paintings as well, and these are indicated.

When I began teaching watercolor I reaped the benefit of contact with a group of people from diverse backgrounds who shared a common passion. Up until then my approach to painting had been largely intuitive, with little conscious thought as to why I painted the way I did. However, in my role as a teacher, I soon found that I had to examine my method of painting — to analyze, synthesize and understand it so that I could communicate in a way that enabled my students to develop skills and produce acceptable paintings within a class session. This turned out to be of benefit to me as well as my students because it allowed me to approach the subject logically, based upon knowledge gained through experience.

It is this knowledge that I want to share with you in this book.

You are not alone

When I began watercolor painting, I was confronted by the same challenges that every beginner faces — a blank sheet of paper and the inevitable questions; what to paint? how to paint it? where to start? the fear of wasting materials . . . For a long time, I painted pictures that were either muddy, tight, overworked, too colorful, too dull or, often, all of the above! However, I persevered and gradually I began to produce paintings that were cleaner and less labored.

As I slowly gained knowledge of the medium, equipment and materials, I also began to develop my powers of observation and selection, becoming more discerning in choosing subject matter. I looked for familiar scenes with some balance and harmony that appealed to me. I limited my palette, painted more broadly, tonally and, above all, kept at it.

I see similar uncertainties in many of my students; they all share a common love for the medium, are as keen as mustard and have varying degrees of ability and expectations — but all require assistance in some way.

The Nag Factor

During classes, I find myself repeatedly giving the same advice to my students, based upon observation of their needs and my own experiences when I was learning. There is a lot to learn, and it takes time and continual reinforcement of the basic principles that are so often neglected in a student's enthusiasm to paint. This enthusiasm can lead to frustration if not properly directed.

Throughout this book, you will find that I repeat myself in terms of technique, advice and observations. This is what I call the Nag Factor — driving home a point by constant reminder or repetition. I often find that I am repeatedly haranguing my students about the same things. Sometimes, when I feel guilty about doing this and I stop for a while, I find that everyone slips back into bad habits. I understand that the process of learning is complex, and there are so many things to remember — so I go back to nagging. It seems to work.

Make your "failures" work for you

Failure is a bit like art — it is often in the eye of the beholder. You may have personal expectations that outstrip your technical abilities. What you consider a failure, others may view as wonderful. Some students regard their paintings as dismal failures, where I would see them as merely unfinished. A level of understanding of the basic skills of watercolor technique, design, composition, drawing, tonal value and color is necessary before it is possible to judge a work properly — particularly your own work!

The good thing about "failures" is that they can become small steps on the road to success. "Failures" increase your knowledge and technical proficiency, provided you adopt a positive attitude and try to learn from these disasters. Examine them critically, seek advice, study the work of others, read books, and so on. A painting abandoned, or torn up in frustration, is a reinforcement of the very failure that frustrates you.

Knowledge and ability tend to creep up on you. Mostly you will not notice this happening — but others will! It is very incremental, impacting on more than just your paintings. You will develop more self-confidence, patience, the ability to see, to plan and to organize.

One of the most obvious signs of a genuine "failure" is overworking. I have noticed that many of my students try so hard — in fact, too hard. They want to succeed so much that they tense up and toil away long after they should have put the brush down. So relax, and be prepared to stop. Take your painting seriously, but be prepared to step back a little and try to focus on what you are trying to achieve.

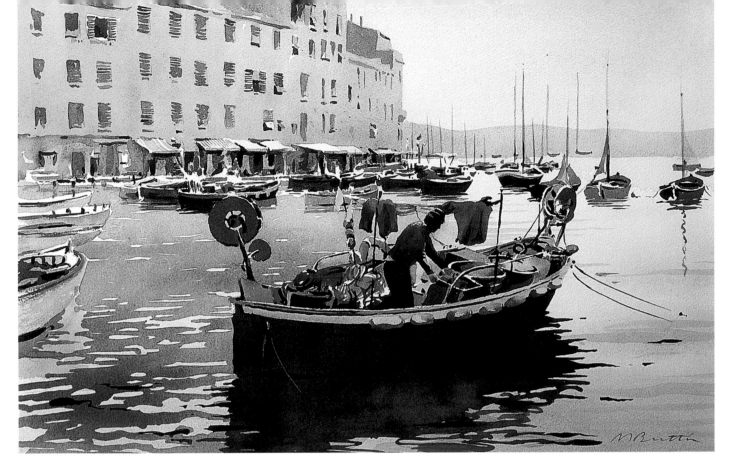

Portofino Harbour, Italy, watercolor, 13½ x 21" (35 x 53cm)

Plan and evaluate your approach

I regard planning as absolutely essential. Solve as many likely problems as you can before you start painting — then you can concentrate on achieving the spontaneity that characterizes all good watercolors. Planning should involve the painting's design, composition, drawing, tonal range, colors to be used, and in what order, before you commence. Work out the aesthetics of your painting and plan your approach accordingly — whether it be a direct, bold application of color or a quieter, more considered build-up of glazes.

This may all sound a bit difficult, but like everything practiced often enough, after a while it becomes almost second nature and does not necessarily take a lot of time. Remember that the time spent planning your approach to the painting is the most important use of your time. Certainly, be discouraged. Be frustrated. But don't give up! It is only human nature to be disappointed when you can't seem to reach that high level of achievement for which you so earnestly strive, and that you see others accomplish. I believe that those who do succeed are not just the naturally talented. They are more likely to be those who persevere, and through their hard work and determination, eventually succeed.

Stand back and view your efforts critically. Be honest, and try to be detached. **Keep in mind that an underworked painting is much better than an overworked one.** Use some assessment criteria. For example, after you've finished each painting use the following 10-Point Analysis Checklist.

10-Point Analysis Checklist

- **Does it achieve my objective?**
- **Have I met the challenge?**
- **Is the design pleasing?**
- **Is the drawing okay?**
- **Are the washes transparent?**
- **Are the colors clean?**
- **Do the values balance?**
- **Have I captured the light?**
- **Is it pleasing to look at?**
- **Is it an improvement on my last painting?**

If the answer to any of these questions is NO, figure out why!! Remember:

> **Failure** leads to **Analysis,**
> **Analysis** leads to **Knowledge,**
> **Knowledge** leads to **Success!**

The pathway from failure to success is a lifelong pursuit, based upon lots of practice and continual appraisal of your progress. It is fraught with frustration along the way — but the rewards will make it worthwhile.

I hope that you will view this book as a source of inspiration. Most of all, I hope you get a sense of the fun and enjoyment you can have with watercolor.

Section 1

Materials and equipment

What you will need for the exercises in this book

A simple list of colors and materials

You don't need very much equipment to be able to start painting in watercolor, but what you do choose can help or hinder you.

Which palettes work best?

It is vital to have ready access to large quantities of pigment, and generous mixing areas. My plastic palette has wells for 18 colors and each well holds the equivalent of a large 14 ml tube of pigment. There are also two generous mixing areas. A close-fitting lid helps keep the colors moist and also serves as a handy tray.

Brushes

I suggest affordable synthetic brushes of good quality. You don't have to use many brushes on a painting, but use as large a brush as possible, for as long as you can. Doing this will allow you to lay washes economically and cleanly, will keep your statements broad and will help eliminate "fiddling".

A good brush should hold a decent amount of pigment when fully charged, and must come back to a point when lifted from the paper.

I suggest a range of excellent, affordable synthetic rounds in sizes 4, 6, 8, 12 and 16.

Use size 8 and 12 wash brushes for laying in broad washes. The brushes I prefer are synthetic, and are shaped rather like an oil painting filbert, enabling me to use them for everything from very broad washes to quite detailed work.

I suggest you buy a full-bodied, **long handled rigger brush** for any loose, suggestive work such as tree shapes and branches, and so on. Riggers can hold plenty of rich, wet pigment and they are capable of very expressive and varied brushstrokes, from thick and bold to fine and wispy. Mine are sables and are the only non-synthetic brushes I own. They are quite cheap.

I use a **wide Chinese waterbrush** for wetting my paper.

Paper

This is the most important item. I use a top quality, 100 per cent cotton 140 lb (300gsm) or 300 lb (640gsm) Rough surface paper, because it handles glazes with ease, has a nice tooth and perfectly suits my very wet approach to watercolor painting. Experiment with different papers to find the ones that you like. Bear in mind that smooth or rough surfaced paper will produce different results.

Painting boards

I suggest you buy lightweight boards of various sizes that you can tape or staple your paper to. I give my boards two coats of white acrylic housepaint to seal them from water damage.

Other equipment

- Make sure you have some good quality HB to 3B grade lead pencils.
- A soft white eraser.
- A hairdryer to speed up the drying process. Mine has a diffuser attachment that spreads the flow of hot air and prevents me from blowing wet pigment all over the paper.
- A water jar — anything will do, so long as it holds plenty of water.
- Masking tape — for attaching paper to the painting board. 1 inch (2.5cm) width is fine.
- An ordinary kitchen sponge is vital for controlling the washes and glazes. I could not paint without one.
- An old towel for controlling the amount of pigment on the brush. Again, I could not paint without one.
- Staple gun and staple remover — necessary for when I stretch paper and for attaching wet paper to the board.

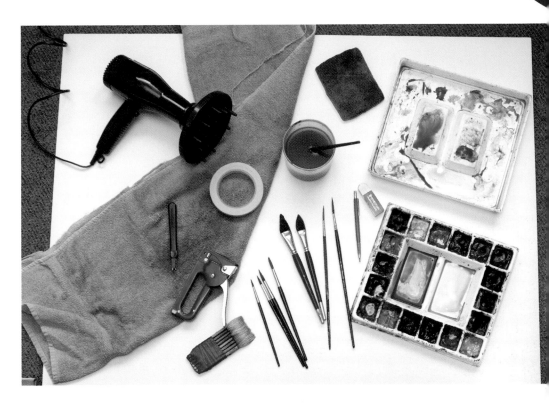

In the studio, I like to work on a table, with my board propped up on my roll of masking tape. Everything is to hand, all my tube colors are already squeezed out into my palette and I have a tub of water standing by. I am ready to paint.

How many colors do you need, and what are they?

Most paint manufacturers offer a wide range of colors in tube form. The best advice I can give you is to buy a basic palette of colors. I also suggest you restrict yourself to using a limited range of colors in every painting, because this will prevent you from introducing a discordant or strident note into the work. If you limit your colors and repeat them throughout a painting you will usually create unity that is pleasing to the eye.

Although I suggest you paint with a limited number of colors they don't have to be the same colors! I have a studio palette with 18 wells and two large mixing areas. This much well space allows for variation in my colors. I believe it is important to keep your eye fresh by constantly working with different colors. A limited palette of 14 colors with some supplementary colors for special effects, will simplify your choices and assist you to gradually increase your knowledge of color mixing.

The colors I list will be those you need to do the exercises and projects in this book.

Which quality paint?

I recommend artist quality paints because they are consistent and provide purity of color and permanence. Artist quality paint is more expensive, but the tubes contain the maximum pigment content. For the extra expense the results are worth it, and the extra strength of artist grade makes it a better buy. However, if cost is an issue, an alternative is to use student quality paints. All the reputable manufacturers make student quality

watercolors which contain less pure pigment and more fillers or extenders. In student quality paints many of the cadmiums and cobalts are substituted by cheaper alternatives. In this case, you'll see the word "hue" after the pigment name. Student paint is sold at one price and offers an affordable selection of colors.

Always check the labels to see that the paints are lightfast and permanent. Ideally, paint labels should carry ASTM ratings. ASTM I is the highest lightfast and permanent rating. Paints labeled ASTM III are definitely not lightfast.

Pan colors are perfect for small-scale sketching on site. I suggest a small pocket palette. I have one that does actually fit into a shirt pocket and it holds 12 half pans of color. Ask to be shown a selection of pocket palettes at your art supply store.

You have to be a bit more disciplined to make sure you keep the pans clean otherwise the colors will become dirty. Replacement pans are available from certain manufacturers. Be aware that pans can cause wear on your brushes. Pan colors usually contain more glycerine to ensure the paint does not dry out in the box.

Once the pans are empty, I merely fill them with the appropriate color from the tubes. I usually do this at least a week before I know I am going to use the palette extensively outdoors. I leave the palette open so that the squeezed pigment hardens — this ensures that the paint is reserved for putting on paper, not all over my shirt, as I wander from painting site to painting site.

A suggested palette of artist's quality colors

I have nominated mostly transparent colors for luminosity, with some opaque colors for granulation and strength. With these it is possible to mix an extensive range of mauves, greens, oranges, tertiary colors and grays. I will explain some important things you should know about color in Section 3.

Basic palette

Supporting colors

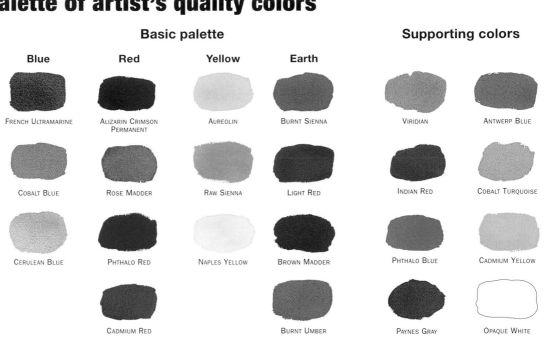

Blue	Red	Yellow	Earth
French Ultramarine	Alizarin Crimson Permanent	Aureolin	Burnt Sienna
Cobalt Blue	Rose Madder	Raw Sienna	Light Red
Cerulean Blue	Phthalo Red	Naples Yellow	Brown Madder
	Cadmium Red		Burnt Umber

Supporting colors: Viridian, Antwerp Blue, Indian Red, Cobalt Turquoise, Phthalo Blue, Cadmium Yellow, Paynes Gray, Opaque White

Characteristics of pigments

Transparent non-staining pigments

These colors are ideal for laying in washes to create beautiful, glowing atmosphere and to portray the effects of light. They are also good for applying glazes because they will not stain other pigments with which they come in contact. Once dry, they can be lightened or removed quite successfully.

As a general rule, use staining pigments first, and opaque pigments last. If opaque colors need to be used early in a painting, use them thinly (mixed with plenty of water), then heavier at the end of the painting.

Transparent non-staining pigments

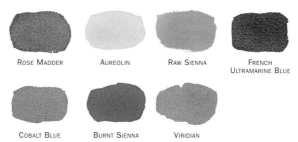

Rose Madder, Aureolin, Raw Sienna, French Ultramarine Blue

Cobalt Blue, Burnt Sienna, Viridian

Transparent staining pigments

These pigments are terrific for creating strong dark mixes, especially when they are combined with opaque pigments (try a Phthalo Blue and Indian Red combination), and for adding intensity to washes. They have tremendous power and will stain the paper and any pigment with which they come in contact. Because of this capacity to stain other colors, generally speaking they should not be used in glazes. (More about glazes later.) Once dry, transparent staining pigments are difficult to lighten or remove.

Phthalo Blue Phthalo Red Alizarin Crimson Permanent

Opaque sedimentary pigments

These dense pigments have great weight and intense covering power, and they will tend to obscure any underlying color. They granulate readily when used with lots of water, and can be used in a stiffer form to overpaint wet colors without dissipating entirely. They tend to "grip" in the wet, allowing us, for example, to suggest distant, misty hills.

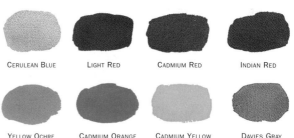

Cerulean Blue, Light Red, Cadmium Red, Indian Red

Yellow Ochre, Cadmium Orange, Cadmium Yellow, Davies Gray

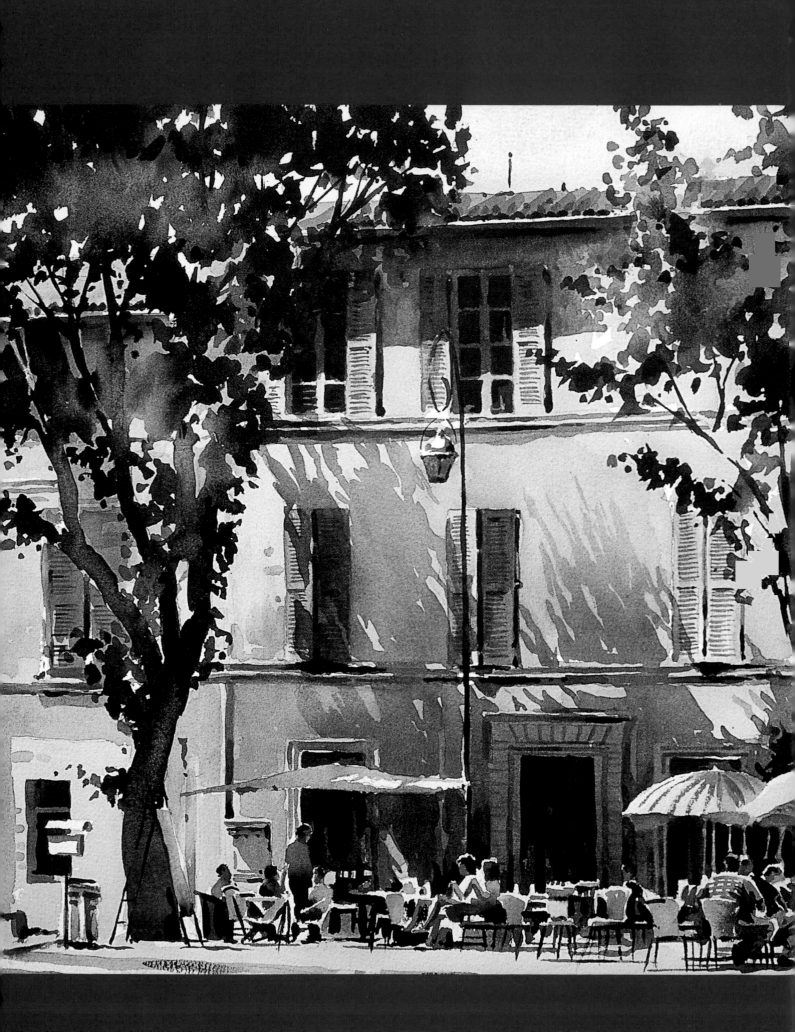

Section 2

The technical basics you should know and practice

These are the things I'm going to nag you about — the fundamental wash application methods that you should understand and practice. It is by your washes they will know you.

In terms of the watercolor medium, float and slosh are words that come to my mind because they so nicely describe the amount of wetness required to lay a nice, "yummy" wash.

Think float and slosh early in your paintings. Use a fully loaded large brush to deposit color into the approximate vicinity required on your paper and let the colors blend seamlessly. If the paint does not flow effortlessly around the board, you are not using enough water — which is called painting too dry. Mop the excess wash from the edge of the paper with a sponge so that you can control what is happening on the paper. I'll show you how this is done later in this section.

Washes — The "Float" and "Slosh" Factors

Before we start on some exercises, let's get a few things clear

1 Do not try to make a brushful of pigment travel too far
This stretches the wash too thinly, causing it to dry out very quickly, usually before you are ready, and this leads to "Cauliflower Country!" (see page 34). The cauliflower is an effect that cannot be successfully rectified, and one that is a dead giveaway to poor technique.

Nothing beats the appearance of a rich wash that has been laid generously with a brush dripping with color. Thinly applied washes usually dry very pale, with brush marks spoiling their transparency and purity. Mistakes like these lay bare the artist's technical incompetence.

2 Clean water does not prevent "mud"
I often see artists who are constantly changing their water because they think doing this is the way to prevent muddy paintings. Not so. Transparent, clean paintings can be achieved with dirty water — "mud" is more often the result of inappropriate mixing of pigments, overworking the brush, getting the timing wrong and not painting tonally. Instead of focusing on the condition of the water, focus on your painting.

All the paintings in this book were produced with water that was quite filthy after a couple of minutes of painting. Whatever else you may think of them, they are not muddy!

3 Know when to work on dry paper
The size and complexity of the painting usually determines the wet/dry requirements for the paper. Usually, if the painting is small (say, less than 20 x 15" or 51 x 38cm), and if the painting does not call for broad, open washes and glazes, then you should be quite happy to work on dry paper.

4 Know when to work on wet paper
I suggest you work on wet paper if it is a large painting requiring big washes and glazes. If you need to retain some definition or white paper, soak the paper thoroughly on both sides and then towel dry the painting surface. Otherwise, plunge right on into the wet surface.

5 Know how to mix color in the palette
Many people have trouble mixing a nice, rich color in sufficient quantities to do the job. I notice that many inexperienced watercolorists slosh a vast amount of water into their palette and then proceed to add a little pigment at a time. They either end up with an insipid tint that will not do the job, or they have to use buckets of pigment to bring the color to the required strength. This method is wasteful, unnecessarily time-consuming and very hit-or-miss.

Instead, aim to achieve a balance. Practice until you are able to load up your brush with plenty of water and still keep it rich with pigment. Begin with only a brushful of water in your palette and add pigment to this until you get the required intensity of color. Test the color on a scrap of paper and if you are satisfied with the hue, increase the quantity of both water and pigment in proportion until you have sufficient quantity of the color mixed in your palette. As you become more experienced and better able to judge the quantities required, you can mix larger volumes from the outset.

6 What happens if you don't mix enough paint?

You will run out of color half-way through the wash and will need to mix more paint — opening up the possibility of some "interesting" learning experiences, with the following possible consequences:

- The paint will start to dry, making it impossible to achieve a nice even wash or glaze.
- You will get a join line on the paper when the initial wash starts to settle, or dry out.
- You won't be able to find the right tube of paint quickly enough.
- If you do find it, you won't be able to get the cap off.
- Then you will not be able to match the color or tonal value.
- You'll make a mess as you fuss around trying to make it work — mud and cauliflowers may abound.
- You'll waste a sheet of paper.
- You won't have much fun.

7 What happens if you mix more paint than you need?

If you mix more than you need, you will have paint left over. However, you will probably use this excess paint later on in the painting, and if you have to discard it, it is mostly water anyway. You may have wasted a little paint — but think of what you have gained!

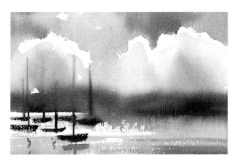

Painted on dry paper

This is a very quick, energetic painting done on dry paper. I allowed the colors to mix freely, while retaining dry paper to define edges here and there. Contrasting (complementary) colors and contrasting edges were used throughout.

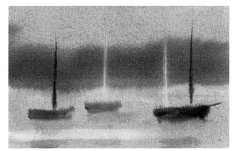

Painted wet-in-wet on wet paper

This was painted wet-in-wet on wet paper with quite strong, opaque pigments. The darks were dashed in just before the paper dried. I used a very stiff mix of paint and wiped the lights out with a barely damp brush.

Painted very wet on dry paper

This ghostly effect was created by floating very wet paint onto dry paper. This allowed me to retain the hard edged light on the top of the boat. All the modeling was done quickly using minimal brushwork. The painting board was tilted to achieve the reflections of the boat.

Colors used were Raw Sienna, Cerulean Blue, French Ultramarine and Light Red.

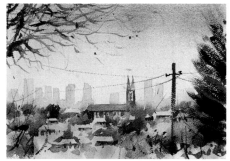

Painted on damp paper

I used successive glazes of French Ultramarine, Rose Madder and Aureolin to get the mood in the sky and foreground. The foreground was treated very loosely, with negative shapes (painting around the object) creating the busy suburban landscape.

19

Getting started

Get organized
Set out all your materials and tub of water.

- Squeeze out tube colors into the wells in your palette.

- Have a selection of 140lb 300gsm paper on hand.

- Tape the paper down onto your board. Taping gives you a secure base for painting and prevents the paper from buckling and curling.

For exercise purposes you can divide the sheets into halves or quarters using tape. You can also economize by using both sides of your paper.

Start with a brushful of color and water in the mixing tray, and then progressively add paint and water until you have more than you think you will need — much more!.

Prop the board up slightly to allow gravity to take its course. Apply rich, watery pigment.

2 Section

"It takes practice to achieve the appropriate balance between the amount of water and paint on the brush relative to the dampness of the paper. With practice and experience you will develop your sense of timing."

Manipulate the board to let the paint spread and run.

When you have completed the work, use your kitchen sponge to mop up excess paint from the edges.

Methods of applying a wash

Do the following exercises with me. There's a big difference between reading about it and doing it yourself — it's called experience, knowledge and understanding.

Washes can be laid on wet or dry paper and can be flat, gradated, variegated or granular. Multiple washes can be laid with any combination of these.

Exercise Beaded wash

You will be working on dry paper

Tape your paper to a painting board.

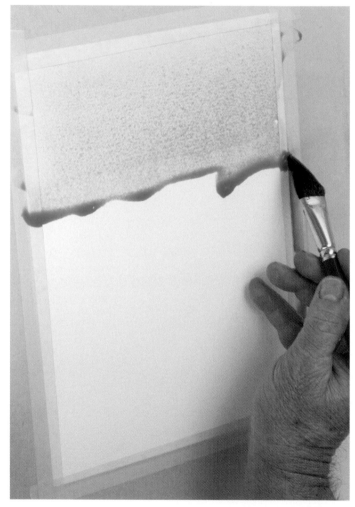

You will be working on dry paper. Draw a bead of pigment down the paper with a fully loaded brush. The paper and board must be at an angle such that gravity, assisted only with the tip of the brush, draws the bead evenly down the sheet of paper, from top to bottom. I suggest you rest your board at an angle of 30-45º, the equivalent of resting your board on a house-brick.

The most common technique problems in watercolor are caused by working too dry and overworking the brush.

Mop any excess paint from around the edges with your kitchen sponge. This prevents moisture being sucked back into the wash as it dries, ruining the wash.

The brush merely facilitates the process. If you use the brush too firmly, you will get visible brush marks on the paper, spoiling the wash. The bead must be applied so that it is on the brink of cascading out of control — the skill is in controlling it, without pause, until you get to the bottom of the paper. Constantly recharge the brush with plenty of paint.

Lay the board flat, and allow the paint to dry thoroughly.

23

Exercise **Floated wash**

You will be working on wet paper

Now try something different. Wet the paper and quickly deposit a blob of juicy color onto the paper. Although it can be applied with a brush, try squeezing the pigment from the brush so that the brush does not touch the paper.

Manipulate the board so that the pigment distributes evenly across the paper. Once again, let gravity do most of the work.

Exercise **Flat wash**

Try working on both wet and dry paper

A flat wash is one that is evenly applied all over the paper — one color, one tone.

Exercise **Gradated wash**

Try working on both wet and dry paper

This time apply one color, and decrease the intensity of pigment as you go, from strong to pale. Now try repeating the exercise, but go from pale to strong.

Grand Canal, from Hotel San Cassiano, Venice

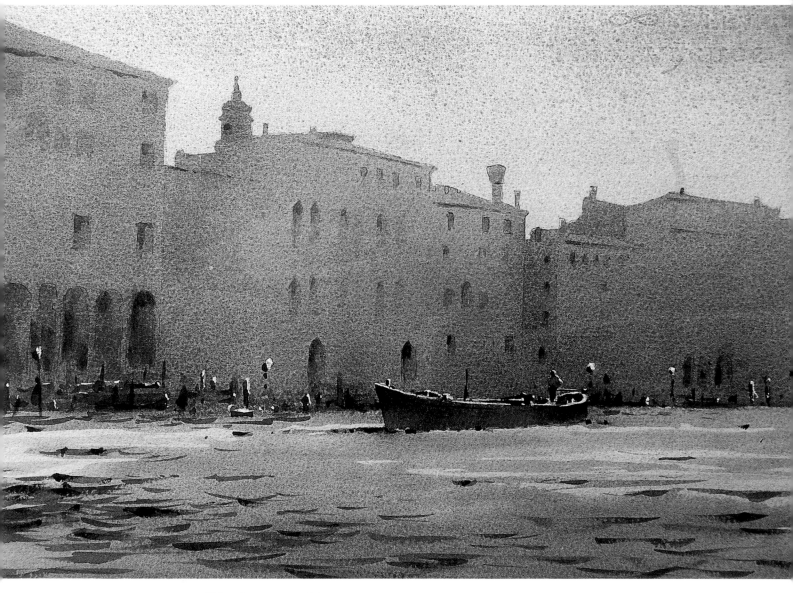

Washes used here

- Variegated wash to establish the background, sky and water.
 Cerulean Blue, Light Red and Raw Sienna
- Broken glaze of Cerulean Blue, French Ultramarine and
 Light Red in water.
- Partial glaze of rich warm color to establish the buildings.
 Details were done one at a time, wet-on-dry.

 # Exercise Variegated wash

You will be working on wet paper

A variegated wash changes from one color to another. Allow the colors to run together. Notice how I divide a sheet of paper to allow me to paint two exercises.

1

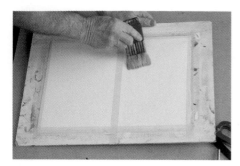

2

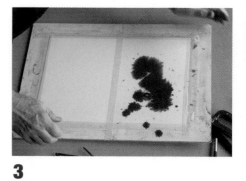

3

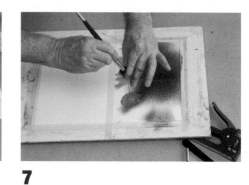

5

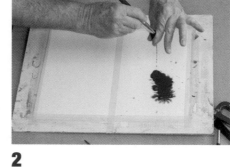

6

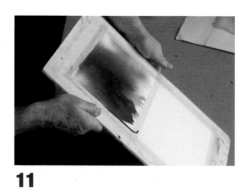

7

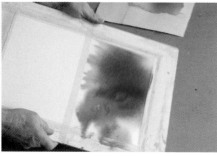

9

10

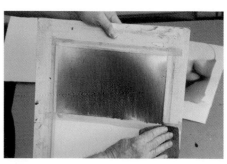

11

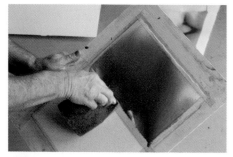

13

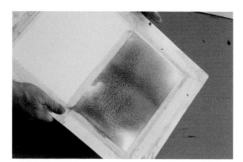

14

15

4

8

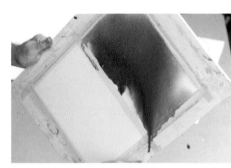

12

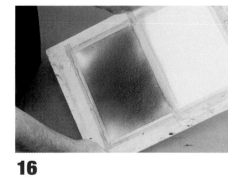

16

17

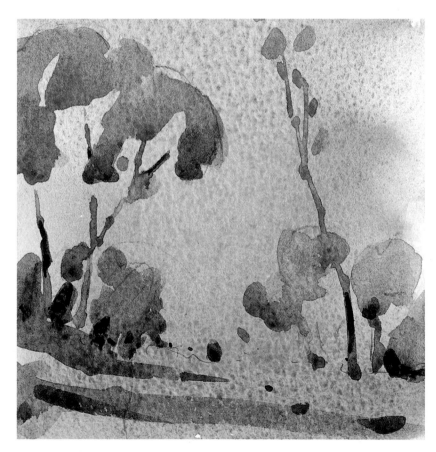

Variegated wash

Here, I developed a simple variegated wash into a somewhat romantic, late afternoon landscape. This small painting, which I called Bush Impression, is characterized by an economy of brushwork.

Exercise Granulated wash

Try working on wet and dry paper

This wash should be applied very wet, using sedimentary pigment to create texture. Colors that lend themselves to a granulated wash are: Cerulean Blue, Light Red, Cadmium Red, Indian Red, Yellow Ochre, Cadmium Orange, Cadmium Yellow and Davy's Gray. When mixed with an earth color such as Burnt Umber, French Ultramarine granulates beautifully.

Important Note

If you apply a wash with the paper at a slight angle, it is better to allow the paper to dry at the same angle.

If you paint a very wet granulated wash with the board flat, then let the paper dry in the flat position.

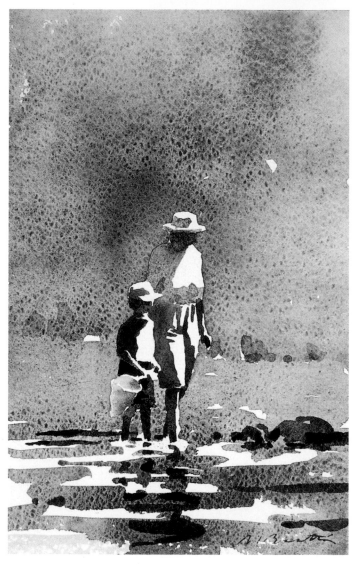

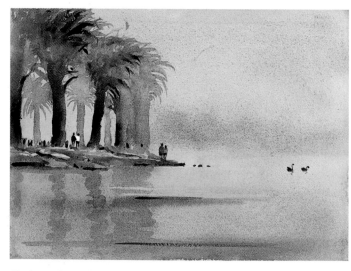

Painted wet-in-wet using variegated, granulated washes to set the scene

This misty, atmospheric painting was done with a reduced tonal range and the result was a moody picture with minimal detail. I used Light Red, Ceruelan Blue, French Ultramarine and a touch of Cadmium Red. The initial wash was established by floating successive washes of Cerulean Blue and Light Red (both opaque pigments) wet-into-wet on damp paper. Even though the painting is calm and soothing, all the contrasts help to keep it lively and interesting.

Granulated wash example

I dropped in Cerulean Blue, Light Red and Yellow Ochre.

Here's another granulated wash

This time I used Cerulean Blue as the base for the entire painting. Here I floated very wet paint onto a rough paper that accentuates granulation.

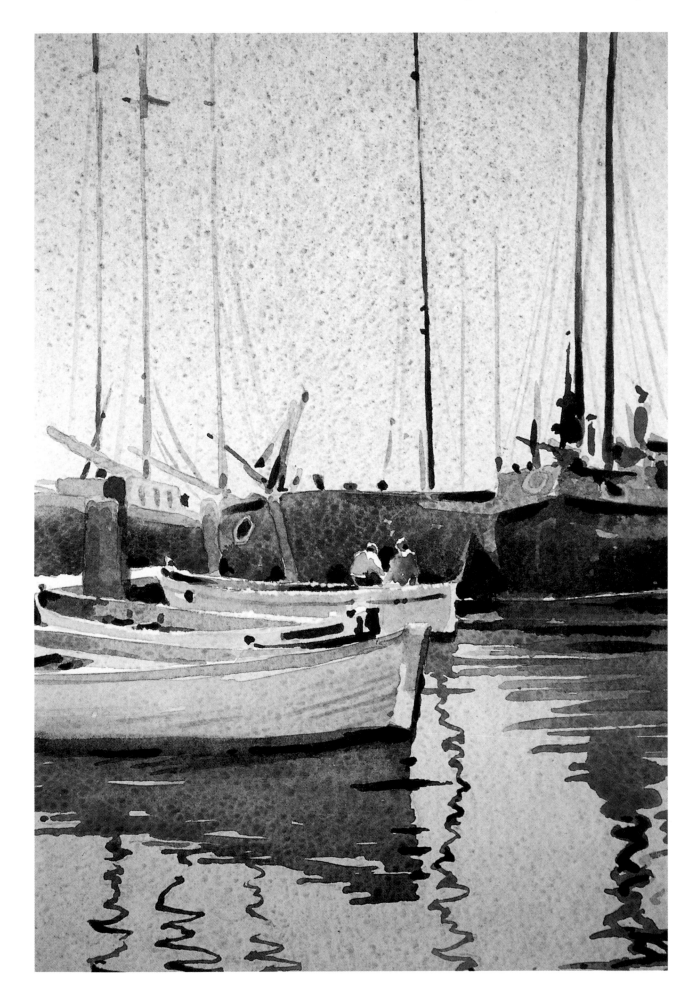

Exercise Dropping in local color

You will be working on wet paper

In the initial stage of a painting, when you are applying the lightest tone and color upon which to build the scene, you can drop in color appropriate to the general area of objects within the scene. This is called "dropping in local color".

The colors are allowed to merge freely and seamlessly (unless you need to retain an edge for a specific shape).

For example, drop in blue where the sky will be, green where the grass will be, or yellow where the sand will be.

1 Thoroughly wet the paper.

2 Soak up excess water from the edges and board with a kitchen sponge.

3 Apply color so you leave the center of the paper white.

7 Tilt the board and allow the colors to blend and merge.

8 Sponge off excess paint.

9 Keep manipulating the board until you have the desired effect.

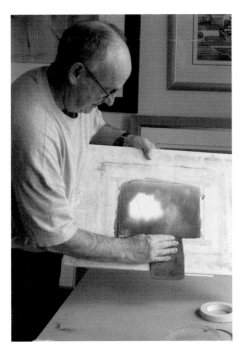

4 Tilt the board and allow the pigment to run. Sponge off any excess pigment.

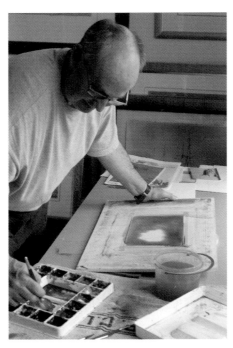

5 Quickly mix up some local color. Pick it up on your brush.

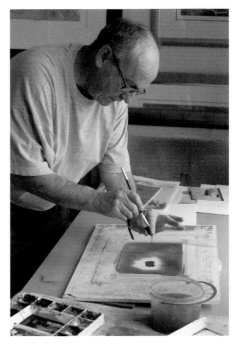

6 Squeeze the brush to allow pigment to drop in the center of the paper.

10 When you're happy with the result you can then build the detail.

Here's how I extended this exercise. I used French Ultramarine and Burnt Umber to create the trees and bushes. Dried it. Then I dashed in a few darks. Then I added a few figures. Now see what happens. Now we have a story. Notice the maximum tonal contrast in the focal point, and the contrasting color temperature. The horizon line is pleasingly varied, and the viewer's eye can travel into the painting. There's more on the importance of figures later on.

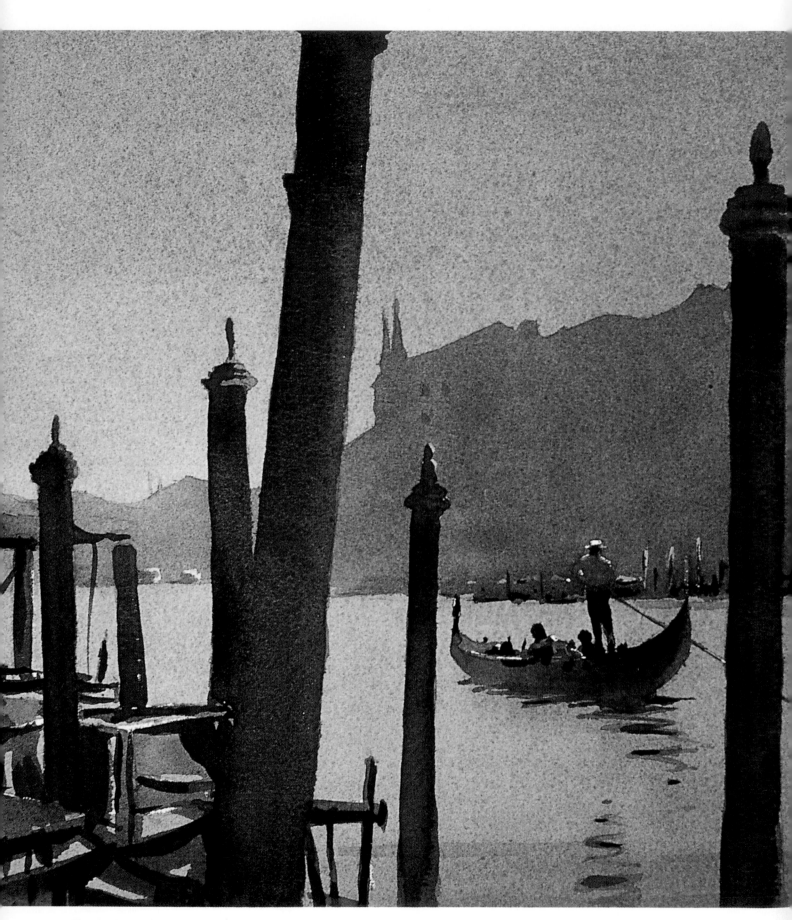

Dusk, from Ponte di Rialto, watercolor, 10 x 14" (26 x 36cm)

Exercise Glazing
You will be working on dry paper

A "glaze" is simply a wash that is laid over an existing wash. The important point is to wait until the previous wash is totally dry before applying the glaze. The glaze should be applied thinly, using lots of water. Pigment should be transparent and non-staining so that the previous, already dry colors will shine through the glaze rather than be overwhelmed by it. It is important to get this balance of color correct.

If you know that you are going to glaze a painting, do it before you put on any dark, thick accents, because these may smudge when the glaze is applied.

Transparent non-staining pigments suitable for glazing

ROSE MADDER AUREOLIN RAW SIENNA FRENCH ULTRAMARINE BLUE

COBALT BLUE BURNT SIENNA VIRIDIAN BROWN MADDER

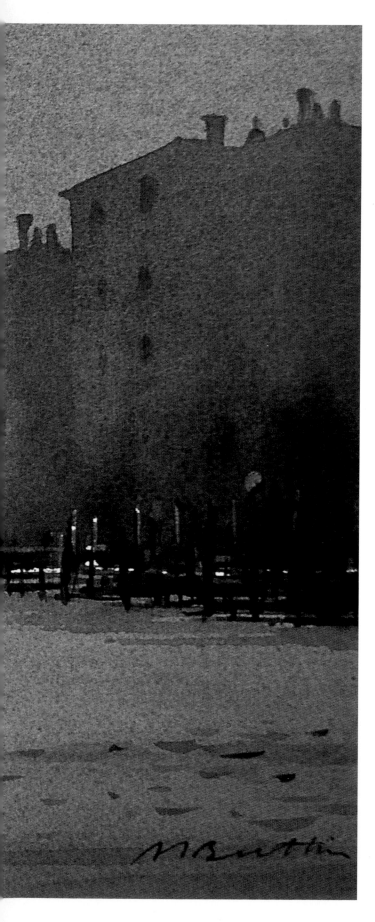

Washes used here
Successive washes of Raw Sienna, French Ultramarine and Bown Madder established the mood. A partial, stronger glaze of the same colors describes the buildings. This painting has minimal detail and strong tonal values.

Harbour View, Sydney, Australia, 15 x 22" (38 x 56cm)

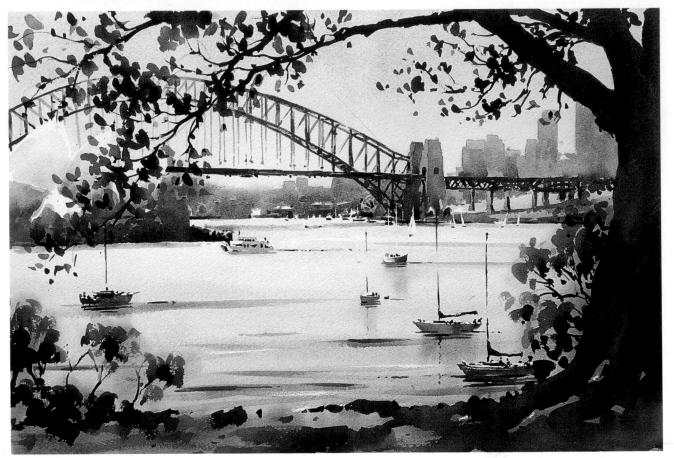

Explaining the controlled wash — step by step

The **controlled wash** method is a very traditional watercolor technique. It is simply a gradual process of building up color and tone using successive glazes or washes, each step being painted "shorter" (painting within the previous glaze), slighter richer in color and deeper in tone.

I believe you will enjoy this method of painting because it allows you to develop the atmosphere, or mood, very early in the painting. Regard this as "setting the stage". Once you have worked out the composition, the tonal values and the overall mood you want to achieve, sketch the subject briefly then float on very broad, wet and loose washes of pigment, dropping in local color and allowing the colors to merge softly and gently in a

controlled manner by tipping and tilting the painting board. (I advise against doing this in a room with good carpet because the runoff can be very messy!)

Glazing onto dry paper allows you further control by retaining some hard edges here and there. While the work is still wet, you can adjust the tone and color of the painting by dropping in more color or lifting it off with a slightly damp brush. These very wet glazes also allow beautiful granulation of pigments to occur, which can assist in creating a desired mood.

Work quickly, using as large a brush as you can. Avoid scrubbing the paper and as soon as you are satisfied that the "stage setting" has been achieved, lay the board flat and allow the painting to dry

completely. **Watch the drying process very carefully**, because the paper may buckle, the pigment may begin to dry unevenly or puddle, which you can carefully run off, constantly drying around the edges with your kitchen sponge.

When you have achieved the desired mood or atmosphere, proceed through each subsequent stage, building up the color and tonal values of the various shapes and elements, gradually bringing the painting into focus, usually drying between each stage. **Paint shorter and shorter**, leaving untouched much of what you did previously. At this stage of a painting, you have usually invested a lot of energy into the initial build-up, so I advise you to be very careful not to spoil all your good work by covering it up

Painting short

Painting short refers to the development of light, form and movement within our paintings achieved by progressively glazing over less of the previous wash.

Exercise Painting short

The scene gradually emerges in this simple demonstration of a classic approach to watercolor.

1 Lay a variegated wash over a simple drawing, establishing the lightest tones. Drop in local color.

2 Paint slightly stronger mid tones over parts of the previous wash. This is called painting short.

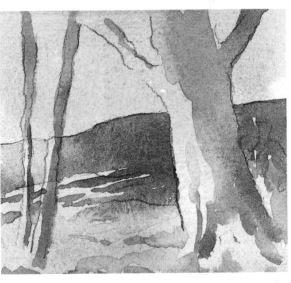

completely with successive glazes. Gradually build up the form so that at the last stage final accents can be quickly and boldly applied to bring the painting into sharp focus. Importantly, I advise you practice **restraint** at this stage because experience has shown that a little goes a very long way.

At each step work over the entire painting, continually balancing shape, line, tonal value and color, creating interesting and pleasing patterns while ensuring an overall **unity of design**. Resist finishing any one part of the painting before another. This requires discipline, but the advantages are that the painting progresses to a balanced conclusion, each part in harmony, which helps to avoid fussy, unnecessary detail.

3 Indicate the dark tones over even less of the scene — paint short again.

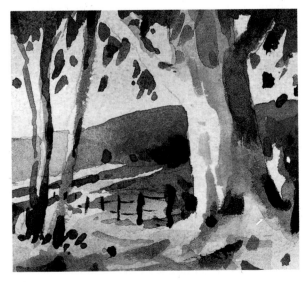

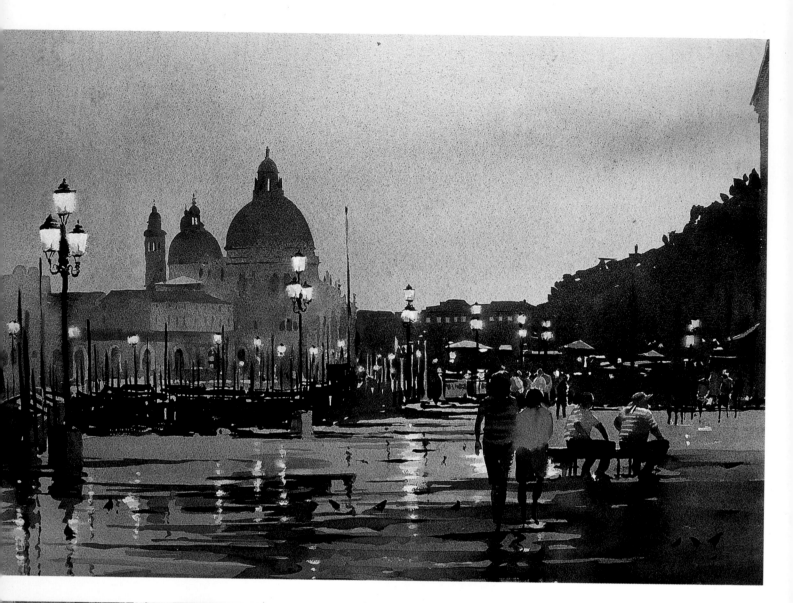

Evening, Venice,
21 x 18½" (53 x 73cm)

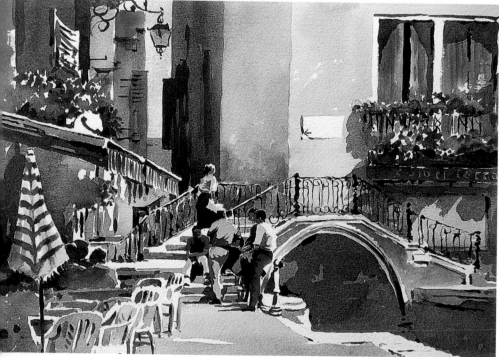

Trattoria at Ponte Calle
Larga, Venice,
10 x 14" (26 x 36cm)

Drying your paintings

When painting on dry, taped paper

Run off all excess moisture before using the hairdryer. If the sheet is too wet, the force of the air from a dryer may blow excess moisture all over the paper, creating a mess. If possible, use a hair dryer that has a diffuser attachment, because this spreads the flow of hot air. While drying the sheet of paper, rub the tape down continually because the heat from the dryer will soften the glue, and the paper will lift off the board and wrinkle. Dry until the paper is flat.

If the wash is granulated let the paper sit for five minutes or so before drying (this allows the pigment to "settle" into the paper) to retain the granulated speckle. If the dryer is applied too soon, the granulation will be bleached out. Alternatively, if you have the time, the best method is to run off excess liquid, lay the board flat and let it dry naturally. This gives maximum character to the wash.

When painting on damp, untaped paper

It is important to only dry the surface of the paper, so that the paper stays wet internally and on the back. This ensures that it stays stuck flat to the painting board, and allows subsequent washes to be workable for longer. Do not dry it so that it curls up off the board.

If it does start to dry out on the back, gently peel the paper off the board and re-wet the back of the paper.

Beware the dreaded cauliflowers!

RIGHT
Drop some color into a wet wash and you'll get a good result.

WRONG!
Now try dropping local color into a damp wash. The result will be a cauliflower!

Let's paint a cauliflower
I suggest you do the exercise and try to create cauliflowers. The reason for this is that if you know how to paint one, you will know to avoid them.

People end up with "cauliflowers" constantly and they tell me they don't know why they occur, or they "just keep happening". Some call them "happy accidents" and turn them into clumps of grass or trees, and so on. Cauliflowers are anything but "happy", because they are caused by a lack of understanding and competence in the medium.

Cauliflowers happen when we get the **timing** wrong by applying a wet brush to a wash that is starting to dry. Here is a basic watercolor truth.

- We can paint **wet** onto **dry** paper.
- We can paint **wet** into **wet** paper.
- We can paint **damp** into **wet** paper.
- WE **CANNOT** PAINT **WET** INTO **DAMP** PAPER.

37

Timing in watercolor

When working wet-into-wet, you must learn to know how much wetness to paint with so that the color either dissipates, merges nicely or grips in the initial wet wash. This is what is referred to as **timing** in watercolor. After a while, you will develop an instinct or "feel" for it.

Remember these general rules when working wet:

- Continue to work the washes while the paper glistens or "shines" when held up obliquely to the light.
- Match the wetness of the brush to the wetness of the paper. Once the shine begins to dull, it is safer to allow the painting to dry completely before continuing.

- If you paint quite wet into the wet wash the added pigment will dissipate and merge freely. This is best when you are developing soft, gently merging backgrounds in the initial stages of a painting (Re-read the section on dropping in local color).
- If you paint into the wet wash using a brush with less water and more pigment, the added pigment will sit and not dissipate quite as freely as before. This is useful for developing large shapes that are more distinct, but still need to have soft, blurry edges.

- If you paint into the wet wash with a very stiff mix of pigment, the pigment will grip, and not dissipate beyond a well defined, but still blurred, edge. This is useful for painting specific objects in mist, for example, trees, tree trunk, boat masts, and so on.

It takes practice to achieve the appropriate balance between the amount of water and pigment on the brush relative to the dampness of the paper. With practice and experience you will develop your sense of timing.

Important Note

You can paint dry into very wet paper, but you cannot paint very wet into damp or drying paper.

As the paper dries, the shine dulls, and the brush must be progressively dried so that it is drier than the surface of the paper to which it is being applied.

Stroke the brush onto an old towel to control its wetness.

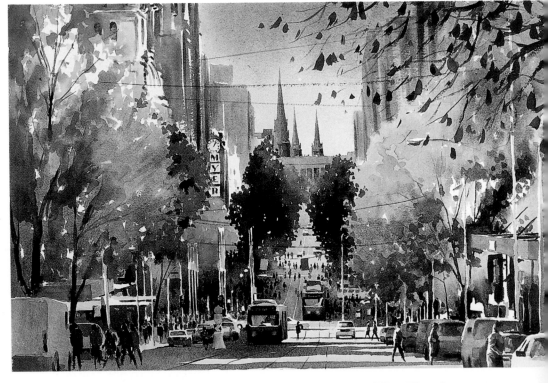

Bourke Street Vista, Melbourne, Australia, 20½ x 28½" (52 x 72cm)

Acquiring brush control

It is important for any professional tradesperson, athlete, craftsperson or artisan to be entirely proficient and comfortable with their tools of trade.

The exercises at the end of this section are designed to make you familiar and comfortable with your tools of trade — your brushes. These exercises should be practiced continuously, because they form the basis of all watercolor painting.

Hints

1 Do all of the brush control exercises on the following pages with a fully loaded brush, and without resting your hand on the paper.

2 Stand when doing the exercises so that most of the action is from the shoulder (in the case of the continuous lines), or the wrist (in the case of the shorter, more expressive marks). Paint with an extended arm, with the brush held firmly but lightly.

3 Try different size brushes and different brush profiles so that you become familiar with all your brushes, and try them on different surfaces of paper — smooth, medium and rough texture.

4 Practice holding the brush in different positions, vertically and horizontally, as well as varying the grip. Try painting with a pencil grip with the hand near the ferrule (the metal bit), as well as with the hand held well back along the handle — my preferred grip.

5 Vary the pressure of the brush to vary the thickness of the line, and vary the angle at which the brush is held to see what impact this will have.

Brush control exercises

Use all your brushes to do these exercises

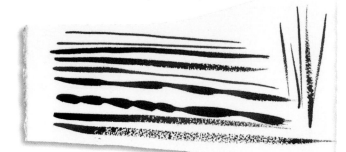

Exercise Straight Lines

- Hold the brush vertically.
- Draw the brush in a steady, controlled manner.
- Repeat these strokes with a very swift action.
- Try different pressures on the brush to achieve different thickness of line.
- Vary the direction of stroke (left to right, right to left, up, down, diagonally).
- Vary the pressure on the brush continuously as you draw the line.

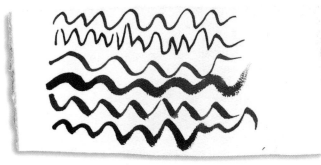

Exercise Wavy lines

- Do these exercises using the same methods as for the straight lines.

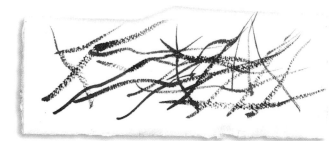

Exercise Random lines

- Hold the brush near the end of the handle, between thumb and forefinger, and flick the fully loaded brush away from you to create a random, varied line.
- Control the action of the brush with your index finger.
- This action is particularly useful in describing tree branches, with the foliage being stated with a series of tadpoles and circular brushstrokes using the side of the brush. While this exercise can be executed with round brushes of various sizes, it is best done with a rigger.

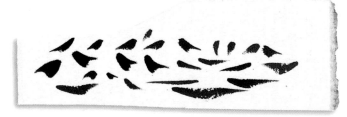

Exercise Tadpoles

- Apply the brush to the paper with a quick flick of the wrist so that the strokes approximate the shape of a tadpole (broad at one end with a tail at the other).
- Alternate the direction and angle at the stroke.

Look carefully at the paintings throughout this book. You will see these tadpoles everywhere masquerading as birds, leaves, dogs, fish, cats, and so on.

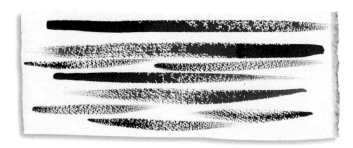

Exercise Drybrush

- With a fully loaded brush, draw a broad stroke across the paper. Continue to use this brush without recharging. As the pigment runs out, you will achieve a drybrush effect.
- Practice this drybrush stroke at different speeds, from a slow, steady pace to a very swift action.

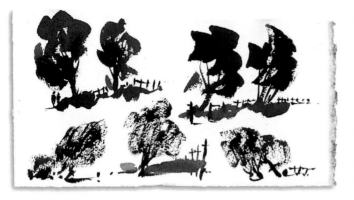

Exercise Using the side of the brush

- Holding the brush loosely in a pencil grip, apply the side of the brush to the paper in a semi-circular motion, both fully loaded with pigment (almost dripping off the brush) and drybrush (a very stiff mixture of pigment, with little water). Be careful not to damage the paper with the metal ferrule of the brush.
- Try these strokes both in a clockwise and anti-clockwise direction.
- Drag the brush toward you.
- These strokes can be used to describe the foliage of trees.

Exercise Calligraphy

- With the brush held vertically, and well back along the handle, describe a series of letters of the alphabet and patterns, varying the thickness of the line.
- Now draw the alphabet (upper case, lower case, roman, italic), your name (forwards, backwards) circles, spirals, squiggles, stars, and so on.

"Happiness is brush control."

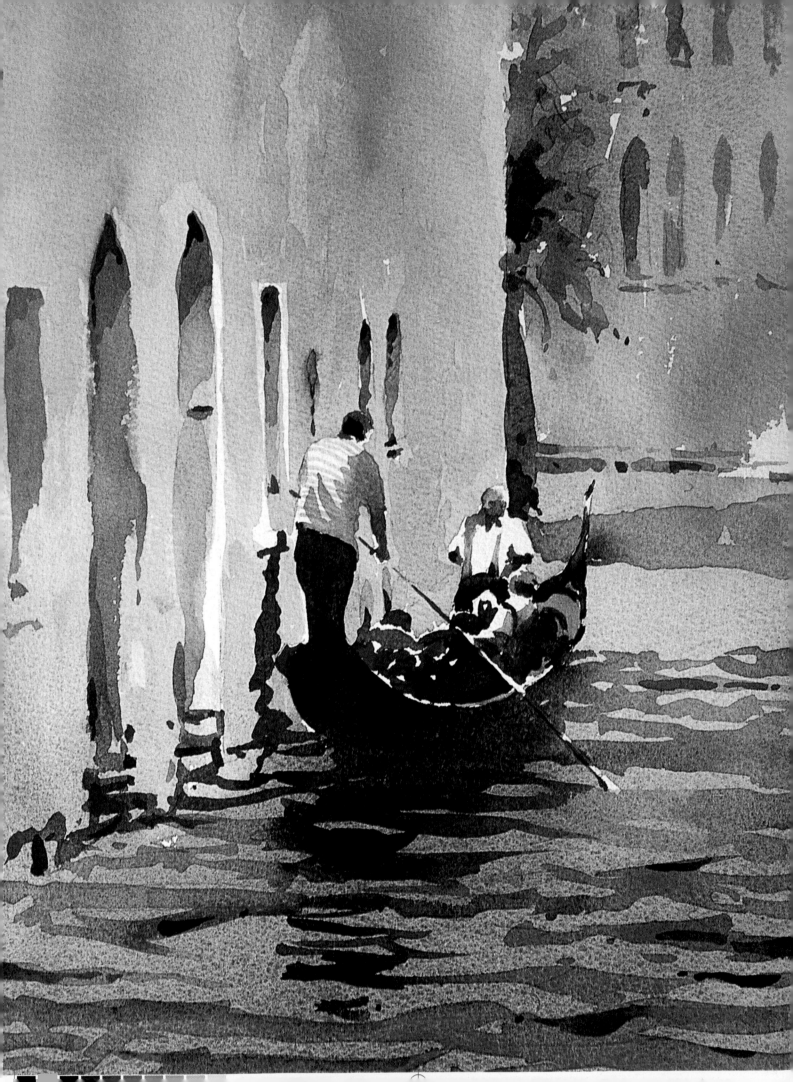

Section 3

Expression simplified

Once you understand your materials and the basic watercolor techniques, you will be free to enter the realm of artistic expression — the really exciting part. In this section we explore ideas that will lift your paintings into the stratosphere of the extraordinary.

The simple ingredients of expression

1 Subject selection

2 Design and composition

3 Drawing

4 Tonal value

5 Color

Simplification is the key

Step back from your subject, squint, and then paint what you see. Squinting cuts out unnecessary detail and clutter, consolidates the big masses and simplifies the tonal range. Whatever detail you can't see from 10 or 12 feet away should not be there. Leave it out!

What makes a good painting?

It's always a good idea to paint subjects that are visually stimulating for the viewer. Always keep in mind that a good painting suggests and abstracts. When everything is spelt out in detail there is nothing, except perfection of technique perhaps, that repeatedly draws a viewer back to a painting.

Successful paintings are often very **simple in concept**, but powerful in their simplicity. They are usually **broadly suggested**, conveying an illusion of reality that grows in strength as you stand back to view them. From a distance, a painting should be **emotionally invigorating**, while close up it should be **technically challenging** — all those dots and dashes, splashes of color and patches of tone will, at a distance, transform into **an image that communicates the artist's vision.**

Mastering technique should be regarded as the beginning of your attempt to create beautiful paintings — it should be taken as the technical starting point in the creative process. I have seen many paintings where the artist has mastered the technique of watercolor, but the paintings still fail because the subject matter is poorly chosen, badly designed, ineptly drawn, is dull tonally, contains no light — or, sometimes, all of the above.

Leaving aside technique, I believe the important ingredients of a good watercolor painting are the ones I've listed in the sidebar.

Of course, this list applies to the type of paintings that I do. I would characterize my style shown in this book as somewhere between abstract and realist. I am not a pure impressionist, nor am I a photographic painter. **Representational painting** bridges the gap between these two extremes. Up close, the detail of a representational painting may appear impressionistic or even abstract, but when viewed from an appropriate distance it takes on a sense of reality — that is, we can recognize what it is that we are painting. **Representational painting is about the suggestion of detail, rather than the recording of detail.**

Artists suggest, cameras record. Inexperienced artists tend to record detail by defining objects too tightly. They paint what they know, rather than what they see. But you're not going to do that, are you?

1 Subject selection **2** Design and composition

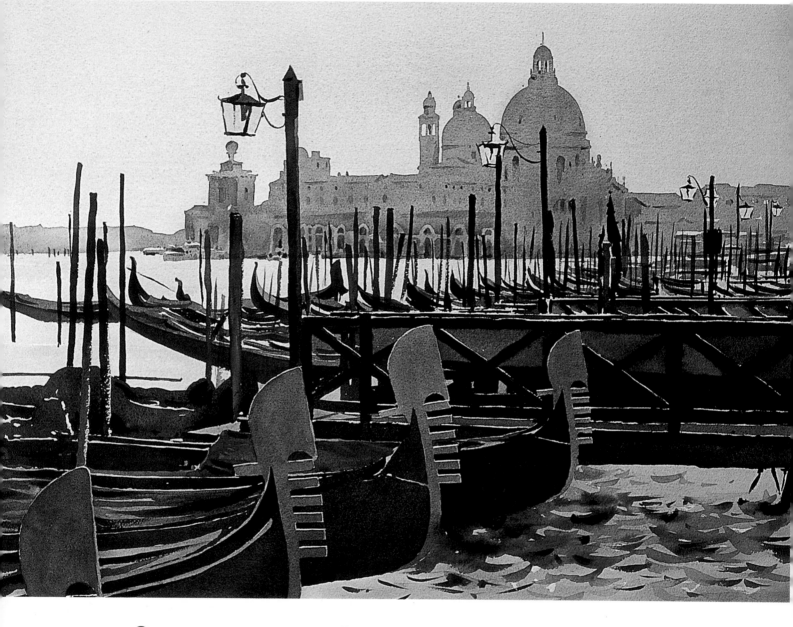

3 Drawing **4** Tonal value **5** Color

1 Subject selection

When you are choosing a subject from a scene in front of you, I suggest you begin with a concept or an idea that interests or inspires you. Look for patterns of light and shade, for color and atmosphere that give life and movement to the image, be it a still-life, streetscape, portrait or whatever. Whether you are painting on site, or in the studio using reference material such as photographs or sketches, try to interpret a scene to suit your concept rather than attempt a literal translation. Instead, use your imagination to create the atmosphere or feeling that you want.

Above all, **simplify** to the point that best conveys your idea.

You can find inspiration in the commonplace rather than the exotic. Really look at the ordinary places, the everyday things around you — from inner city streetscapes, tranquil parks, seascapes and beaches, the local wood to the plains and distant mountains, and beyond! It is possible for an artist to thrive on the hustle and bustle of the city streets. There is a multiplicity of subjects in the beautiful tree-lined avenues, the cast shadows from the tall buildings, the colorful markets and the cafés — all these can provide you with an endless source of inspiration that changes with every season.

The material is there — all we have to do is recognize it, absorb it, and then paint it!

Unusual subjects

You can paint almost anything. I made a series of paintings of old trains in varying stages of decay and treated them in an abstract manner, concentrating on close-up snapshots of the subject. These paintings were interesting and dramatic compositions involving color, tone and texture. I searched carefully for pleasing designs with contrasting shapes and patterns. My interest in Australian history dictated recognizable and accurate renditions of these trains (or else train enthusiasts would probably have had my hide).

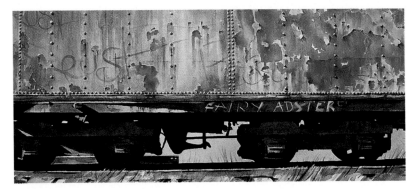

Fairy Adster, 18 x 40" (46 x 102cm)

Peace Train, 22 x 30" (56 x 76cm)

Bucket of bolts, 22 x 30" (56 x 76cm)

your quest to simplify a complex scene and turn it into a work of art

Unusual formats

Try thinking outside the rectangle and stretch your compositions to include panoramic and vertical formats.

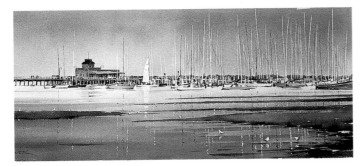

Reflections, St Kilda, 15 x 30" (38 x 76cm)
The overly horizontal nature of the scene was brilliantly balanced by the vertical masts of the boats and their reflections.

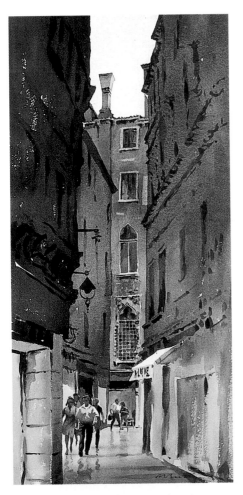

Marzana dell Capitello, Venice, 73 x 28" (180 x 71cm)
I made use of this vertical panorama to capture the feeling of the narrow, canyon-like setting of this Venetian laneway.

Capturing different moods

You can use all the technique tools to help you suggest a powerful message. Here are two different treatments of exactly the same scene. All I did was vary the technique to get two very different results.

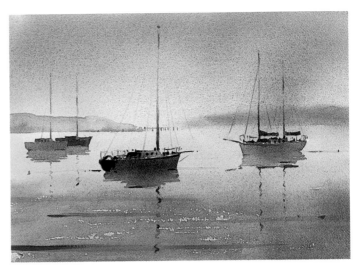

This atmospheric, granulated piece was achieved with glazes dry-brushed to allow the complementary color to sparkle in the foreground.

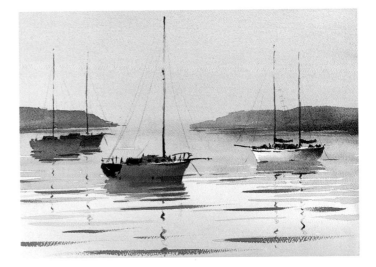

A partial, broken glaze describes a different sort of light, which is less diffused. A wider tonal range, with lighter lights and darker darks, and sharp edges add impact.

2 Composition and design

There are many rules about good composition and design and they are all valid. My way of approaching these rules is to be aware of them, but to treat them more as a subconscious checklist rather than a recipe. I believe it is possible to so burden yourself with rules and things to remember that it can take the spontaneity and fun out of painting — **and painting is meant to be fun!**

A commonsense approach I recommend is: **If it is pleasing to look at, then it is good design.**

I find that, like choice of subject matter, after a while composition and design become a matter of instinct and, as your experience and confidence grow, so too will your knowledge and level of sophistication.

Study the paintings of artists whose work you admire, and analyze their design, rather than try to learn lists of "rules" about composition and design.

Rather than list them here, I mention many of the composition and design aspects as we go through the exercises in this book. Look for these design ideas as you work your way through. You are much more likely to remember them if they are drip-fed to you over a period of time.

As I reviewed and analyzed the paintings in this book, I discovered things about them that I didn't consciously plan, they just happened (some bad, but mostly good).

When it comes time to follow the projects in Section 5 of this book you will see how to work with compositional sketches, color notes and design diagrams. In time, you will become more proficient and then you can decide to either continue working in this way or you will find that the serious planning will become instinctive, largely taking place in your head at the beginning of the creative process as you look for subjects to paint.

Crop the scene to reduce complexity

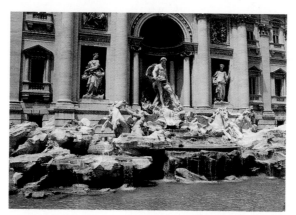

This is the fabulous Trevi Fountain in Rome. Of course any artist would like to capture a magnificent subject like this in their sketchbook. But the full scene is quite difficult. You can reduce the complexity of any scene by cropping the view! Simple!

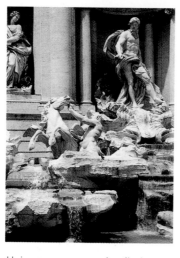

Using my camera viewfinder I simplified the view.

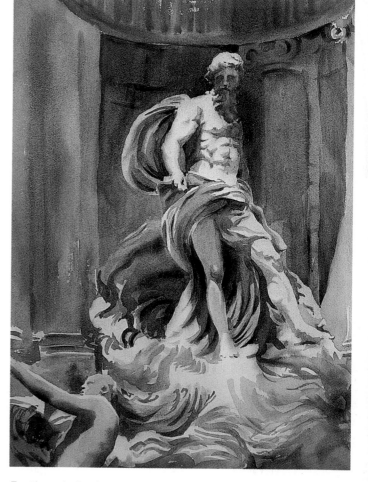

For the painting I zoomed in even more, limited my colors, and this is the result.

Crop the scene to focus attention

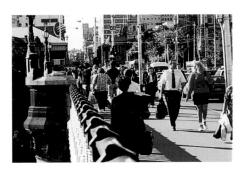

A favorite subject of mine is the way people move and interact in a busy city. This sunny afternoon in Melbourne had bright colors, strong shadows, lots of movement and activity. It was a happy scene with a great-to-be-alive feel.

I cropped the scene so that my pen and wash preliminary sketch focused on the people, not their environment. The pen and wash sketch crystallized my ideas. I cropped the top, bottom and left to produce a horizontal format. I needed to extend the right. The challenge was to capture the same light, movement and spontaneity in the painting itself. But, at least I had a plan.

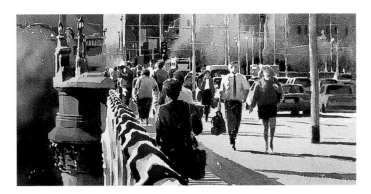

The soft, indistinct passages in the background of the finished painting counter the strong, direct statements elsewhere, and add depth. Notice the quick dry brushstrokes on the figures, and how this reinforces the feeling of movement. How many contrasts can you see in this painting? There are lots — color, tone, edges, line — but the painting retains its balance.

Here's how to tackle a complex background

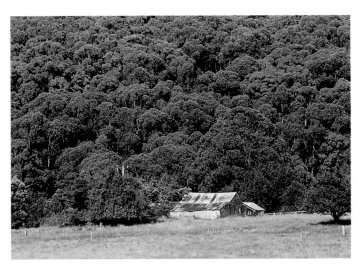

I was attracted to this ramshackle collection of buildings just off the Melba Highway, but just look at that towering background.

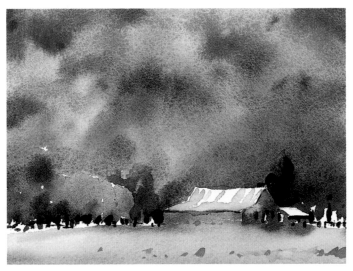

Because the focal point of the scene was the collection of buildings, the background could be downplayed. I observed the colors and form of the background trees and tried to capture it using a quick, simple, variegated wash. Strategic strong dark accents and bright, reserved white highlights focus the viewer's attention even more.

49

Exercise Deciding on the message

Reflections, St Kilda, 11 x 15" (28 x 38cm)

Paper 140lb (300gsm) Rough

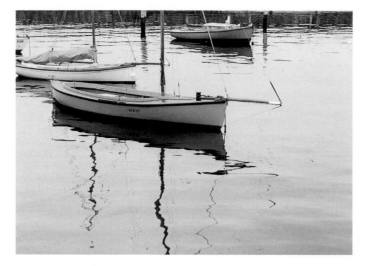

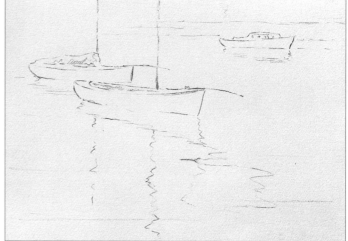

You can do a lot of the composing in your camera's viewfinder. Looking at the scene I was inspired by the water, so I pushed the boats to the top half of the painting, creating lots of room for the reflections in the foreground. The reflections are the message.

When you make your rough pencil sketch move the background boat a little to the right, to create a counterbalance for the two closest boats. Don't bother about the rigging or final detail — you will do this with your brush later.

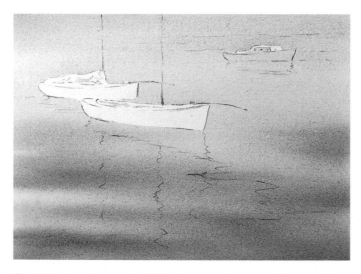

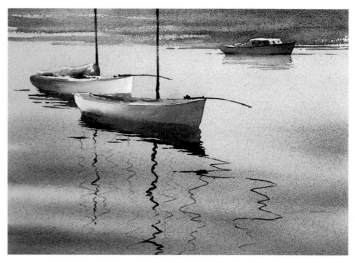

The following stages should be done wet-into-wet. Thoroughly soak the paper, towel dry the surface and float on a variegated mix of **Cerulean Blue**, **Aureolin** and **Alizarin Crimson Permanent**. Keep the top cool (**Cerulean Blue**) and the middle distance a warm gray mix. Then model the foreground swell with stronger mixes of the above colours. Make the sea-green color by combining **French Ultramarine** with **Cerulean Blue** and **Aureolin**. Allow the surface to dry thoroughly.

Begin to model the broad shapes, working from the top down. Use varying mixes of all the pigments, gradually increasing in strength as you work down. Notice the reverse counterchange on the hulls of the foreground boats — dark to light, then light to dark. Dry with a hairdryer.

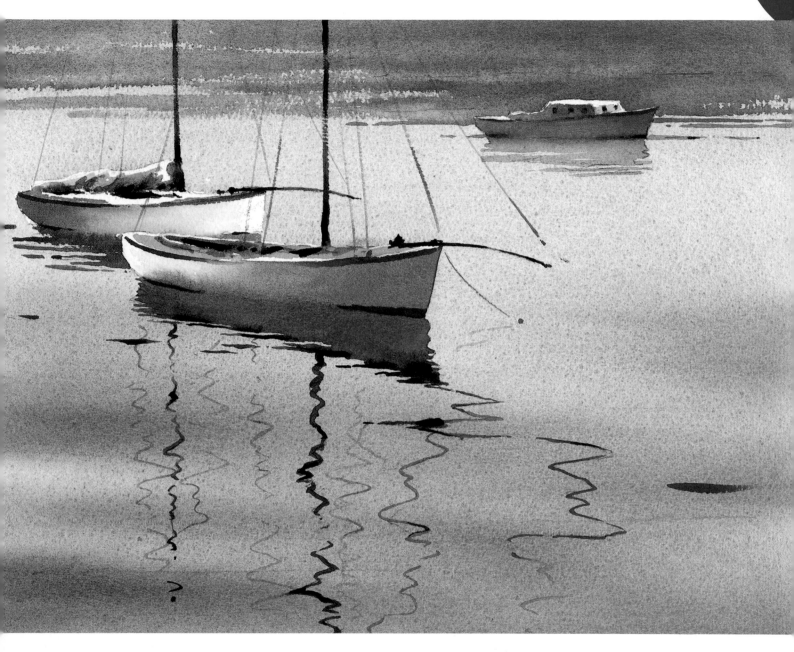

Note
See pages 60-63 for two other paintings of boats in which we will be using exactly the same colors as here, but in such a way that we get totaly different results. Here, we allow the paints to mix and merge on damp paper

Paint the final accents with thicker pigment on dry paper to project the light into the painting. Now's the time to suggest the rigging and other boat details.

The way the two foreground boats overlap and how the slight angle of the first one creates tension with the one behind, makes the design interesting. The activity of the top half is countered by the simplicity of the bottom half. The masts and their reflections push out of the picture plane, creating a vertical unity that holds the scene together.

3 Drawing

In representational art, the drawing is the foundation upon which the painting is built. With a weak foundation your painting may collapse, while having an overly strong foundation is an uneconomic waste of your resources and energy.

Your paintings should rely on good drawing in terms of **tone**, **line** and **shape**. Before you start painting, make a number of **thumbnail sketches** which should be very brief and take only a minute or two. These sketches are quick primary statements of composition, shape and tone, and their very brevity allows a number of ideas to be tested. By quickly brushing color on a pen drawing, very useful color notes can be created.

Use the **drawing as a planning tool**. Try to solve some of the compositional problems, such as where to place the shapes, tone and shapes, and so on, before you begin painting because, once the paint starts to flow, there are enough problems to worry about — controlling the washes, mixing pigments, judging tones, drying the paper . . .

When you have decided on the size of your proposed painting, it will be helpful to you if you indicate lightly about six **reference points** within the picture border. These points can be used to **key** in major elements of the painting, related to both the picture border and to each other. Working with a key will ensure that your drawing actually fits within the picture border at the required size and be compositionally correct. It's a little like the 'dot to dot' drawings we all did as kids.

Sound drawing is an essential part of the planning process. Careful drawing does not mean detailed drawing, it means placing only those lines necessary to convey the **essentials** of the scene and that will guide you through the painting. **It is your watercolor roadmap.**

Likewise, accurate drawing does not mean detailed drawing. It means that the essentials should be placed correctly relative to each other with the main shapes described truthfully.

Unplanned drawing — Wrong!

Well planned drawing with reference points — Correct!

Observation is the basis of good drawing, so observe carefully and pay attention to proportions and perspective. Look for the relationships within an object and between objects.

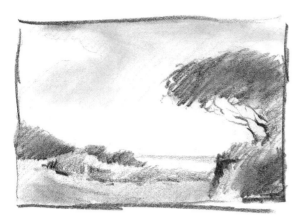

Tonal sketch

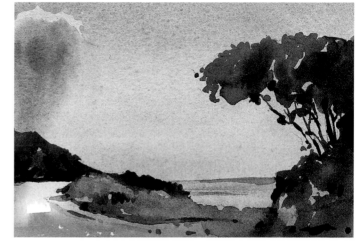

A simple plan makes a simple but expressive painting possible.

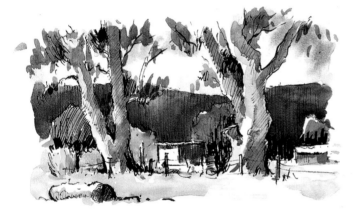

An on-the-spot pen and wash color study

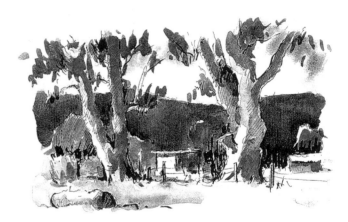

The tonal version

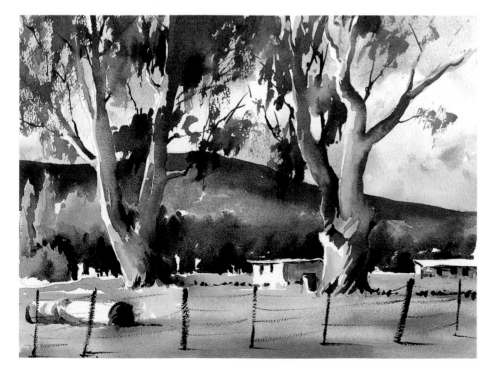

Back in the studio I worked from my pen and wash sketch to produce this painting. Notice that I modified the shape of the hills and introduced some mid tones and vertical shapes. I added the foreground to give the impression of depth. I used a quick, drybrush stroke to assist the eye to travel through the fence and beyond. There's freshness in the light of the original pen and wash sketch, but this version is not too bad.

4 Tonal value

Tonal value simply means the amount of light and dark there is in a scene. Throughout any painting keep in mind that you are painting the effect of light on the objects in the scene. In other words — paint the tonal values.

Paintings that have strong, balanced patterns of light and shade are usually the ones that attract most attention. When looking for subjects to paint, observe the pattern of light and dark in the scene.

Squinting helps to cut out the unnecessary detail and simplifies the picture down to the major shapes and tonal masses.

Simplification!

Reduce the tonal pattern down to three approximate ranges — light tones, medium tones and dark tones. There will invariably be an overlap between the ranges, resulting in ill-defined edges. Great! This helps avoid all that unnecessary detail and also creates a little mystery, which in turn gives the viewer an opportunity to interpret what you have done.

Simplification!

Look for areas of tonal counterchange or contrast. This occurs when the lightest light is adjacent to the darkest dark in the picture. This is most useful when you want to lead the viewer's attention to a particular area. You just have to be careful to keep the counterchange in harmony with the overall pattern of light and dark.

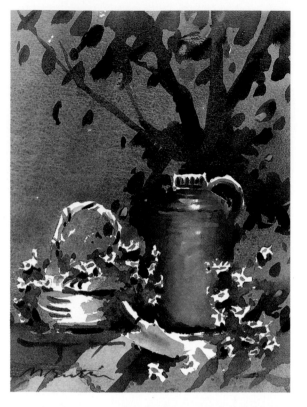

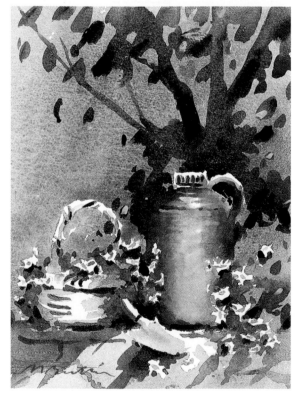

Reserving whites

Reserving (not painting on) the white paper is one way to achieve the lightest light. In my initial tonal sketch for this still life I planned where my highlights and lightest lights would be. I simply painted around those areas, leaving them white. You may also use masking fluid, however, there is more opportunity to learn and more fun, without it.

For this painting I used a wider palette of colors — Raw Sienna, Cobalt Blue, Rose Madder, Cadmium Red, Light Red, Burnt Sienna, Aureolin, French Ultramarine and Cadmium Orange.

Tonal plan

This mono version shows the tonal divisions.

Reserving whites and varying edges

Another form of contrast that makes a picture interesting and introduces atmosphere, is to vary the hard and soft edges. This direct, spontaneous sketch makes the most of hard and soft edges, reserved white paper and strong, clean pigment. The mono version on the right shows the tonal values.

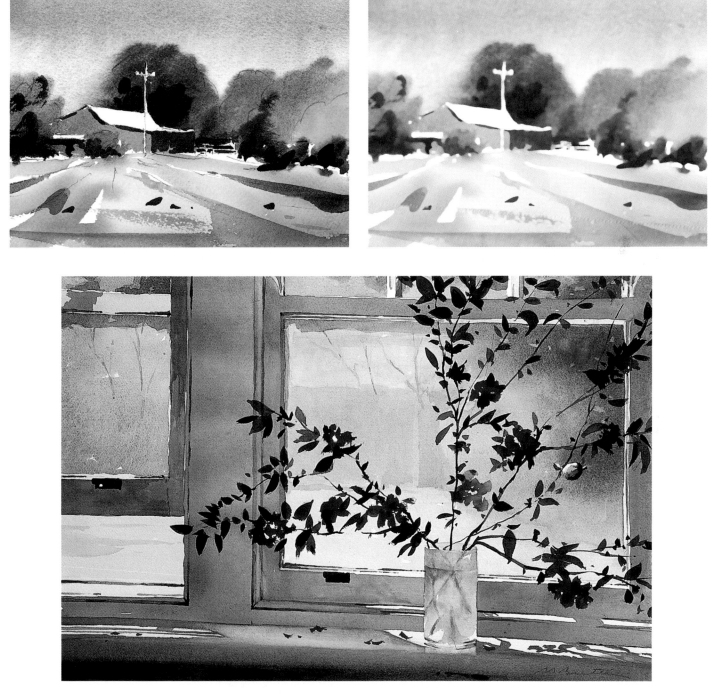

Suggesting depth through tone

The dark tones and rich pigment in the foreground and the misty mid-tones in the background encourage the viewer to look through the window into the garden beyond. The formal, rectangular structure of the window, (including the inviting open window), is complemented by the very informal nature of the branches. Notice the reserved white paper for highlights.

5 Color

While the use of color in a painting is extremely important, it is not as critical to its success as the other elements (choice of subject, design, drawing and tonal value range).

A basic understanding of color principles, and how to work with a limited palette, will benefit your painting enormously, creating unity and enabling you to establish mood and atmosphere.

A limited palette will simplify your choices and assist you to gradually increase your knowledge in the use of color mixing.

I paint with a limited palette of usually no more than four or five main colors, with a few bright, often primary colors tossed in at the end. I either mix my colors in the palette or allow them to mix on the paper, I tend to paint with

a lot of grayed and tertiary colors, ensuring that my paintings will have color harmony.

If you manage to get all the previous elements working (choice of subject, design, drawing and tonal range), you can make a successful painting with any number of colors.

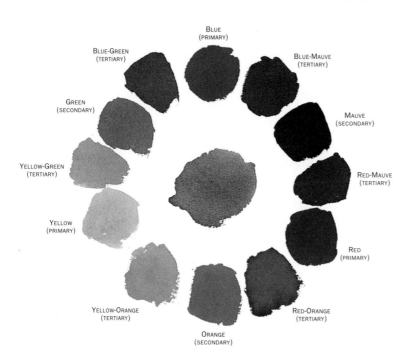

BLUE
(PRIMARY)

BLUE-GREEN
(TERTIARY)

BLUE-MAUVE
(TERTIARY)

GREEN
(SECONDARY)

MAUVE
(SECONDARY)

YELLOW-GREEN
(TERTIARY)

RED-MAUVE
(TERTIARY)

YELLOW
(PRIMARY)

RED
(PRIMARY)

YELLOW-ORANGE
(TERTIARY)

RED-ORANGE
(TERTIARY)

ORANGE
(SECONDARY)

Exercise **Paint a basic color wheel**

For your primary blue use French Ultramarine, for primary red use Alizarin Crimson Permanent and for primary yellow use Aureolin. The secondary and tertiary colors are mixes of the primaries. The vibrant gray shown in the center can be made by combining all three primary colors, or any two complementary colors. Paint the exercise on dry paper.

Exercise **Now join the colors**

Try the exercise again, but this time as you paint tilt the paper to allow adjacent colors to merge and mingle.

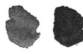

FRENCH
ULTRAMARINE
BLUE

ALIZARIN
CRIMSON
PERMANENT

AUREOLIN

COMPLEMENTARY COLORS
MIXED TOGETHER

Exercise 3 A complementary color painting

Blue and gold — these are the classic colors of the Australian bush in high summer. Such harsh, glaring light calls for a quick, dynamic approach full of energy and urgency. The aim is to make a bold watercolor sketch that captures an instant in time.

The simple ingredients of expression

REFERRING TO THE COLOR WHEEL, MOST OF THE PAINTING IS DONE WITH A HARMONIOUS COLOR SCHEME (FROM THE SAME SIDE OF THE COLOR WHEEL).

BLUE (PRIMARY)

YELLOW (PRIMARY) RED (PRIMARY)

SMALL, VIBRANT ACCENT PUT IN WITH A COMPLEMENTARY COLOR (OPPOSITE SIDE OF THE COLOR WHEEL).

ORANGE (SECONDARY)

What you will need

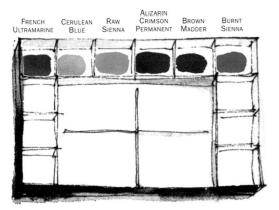

FRENCH ULTRAMARINE · CERULEAN BLUE · RAW SIENNA · ALIZARIN CRIMSON PERMANENT · BROWN MADDER · BURNT SIENNA

Tape down your paper. Make a rough pencil sketch.

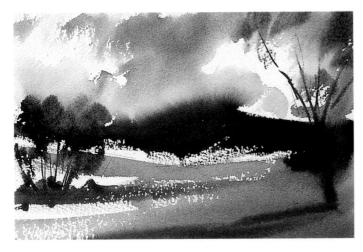

You will be working on dry paper. Using all the colors in the list, either mixed or separately, state the broad impression. Keep it immediate and simple. Work from the top down, and as the painting progresses use a stiffer mix of pigment on the brush. Use vigorous brushstrokes. Allow to dry.

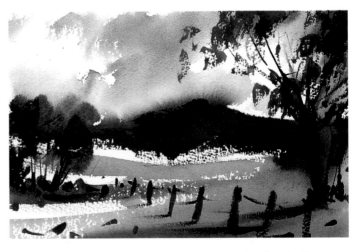

Using thicker pigment put in the foreground details, the fence and the darks in the trees. Notice how some of the foreground complementary color is carried into the trees.

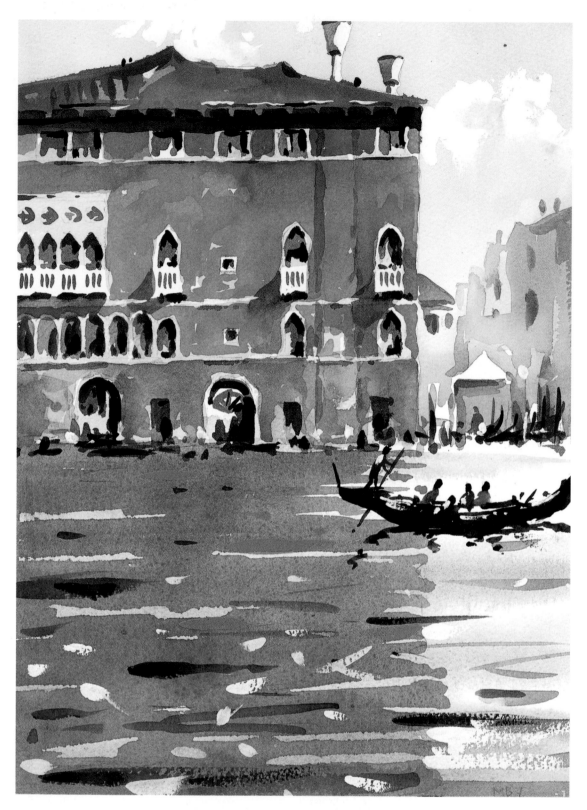

Painting with complementary color

This Venice scene uses the complements of red-orange and blue-green. Despite the fact that the building is the largest shape, it is the gondola that is the focal point. I made sure this was so by making it the darkest tonal value and placing it in the lightest tonal value area. There are a lot of defined edges and shadows in this sketch, which help to express the brightness of a summer day. Notice the expressive brushwork.

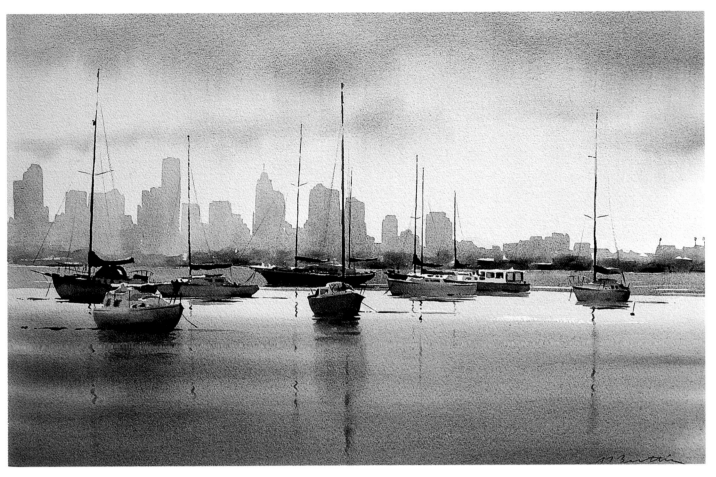

Painting with a limited range of colors

This painting of Melbourne from Williamstown uses contrasting mauve grays with yellow. The focal point of the painting is the line of boats in the middle distance. Although few colors were used, the painting is full of light and atmosphere.

Painting with grays

The predominant color theme is gray. The calm stillness of the foreground contrasts starkly with the threatening turmoil of the sky. The figures, simply stated, are vital to the success of the painting.

Exercise How to paint an expressive picture using only a few colors

 Couta Boat

Over the next few pages I am going to take you on a watercolor jounry using a limited palette of four colors: Cerulean Blue, French Ultramarine, Alizarin Crimson Permanent and Aureolin. You will discover how versatile a limited palette is, especially when coupled with a variety of techniques of putting the paint onto your paper. From the primary colors (red, blue and yellow) you can mix a whole range of secondaries, tertiaries and grays. You can mix the equivalents of Raw Sienna, Viridian, Burnt Sienna and Brown Madder, and a bunch of warm and cool grays all the way to black. The pigments I have chosen have enough strength in their pure state to create very strong darks, and pure clean tints when mixed with loads of water. They stain, they granulate, they do all sorts of wonderful things provided you don't puddle around with them. The only thing they don't do is mix a bright red, so we'll cheat a little and use a tiny bit of Phthalo Red for accent at the end of each painting.

In each case my inspiration for the seascapes on the following pages was the utter tranquility and glass-like surface of the water, with the gently undulating reflections of the classic boats creating a mood of peaceful serenity. These are the types of scenes that watercolorists dream about.

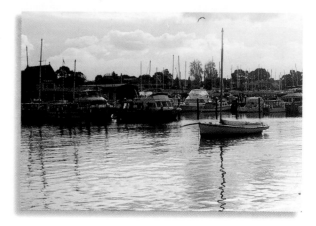

The scene — a classic Melbourne couta boat popular with enthusiast sailors and built to fish for baracouta in Victorian waters.

With this exercise we are going to mix all the colors in the palette and paint the scene with a varying mix of cool grays.

What you will need

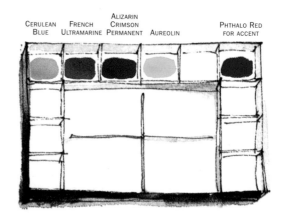

CERULEAN BLUE FRENCH ULTRAMARINE ALIZARIN CRIMSON PERMANENT AUREOLIN PHTHALO RED FOR ACCENT

Paper
140lb (300gsm)

Masking fluid

Brushes
Synthetic wash #12
Synthetic round #8 and #12

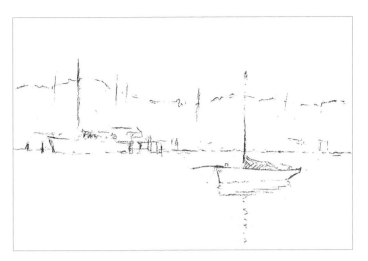

Simplify the scene. Draw the shapes with an HB pencil with just enough information to guide the brush through the painting. Then tape the paper to your board and rest this on your masking tape roll so it is tilted at 5 – 10° to the horizontal.

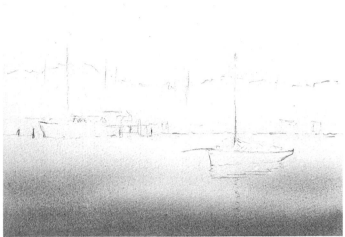

In your palette, mix the three colors together to make a generous puddle of warm, yellow-gray. Flood this wash, very wet, onto dry paper, reserving the white, dry paper on the top of the couta boat. Immediately lay a stronger mix on the immediate foreground. Allow to sit for a few minutes to settle the paint, then dry with a hairdryer.

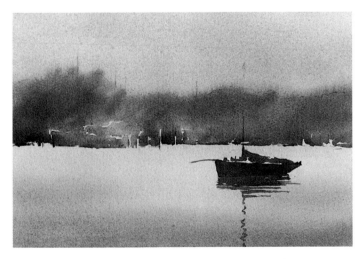

Wet the sky with water and float in a light, warm red-gray. While this is wet, paint the shore with a stiff mix of neutral gray. Vary the mix, and make sure the waterline is broken, suggesting boats, jetties and masts.

Paint the couta boat and its reflections using a stronger, warmer gray. (Notice how I painted the boat and its reflections as a unit.) Retain some light accents along the deck of the boat. Dry with your hairdryer.

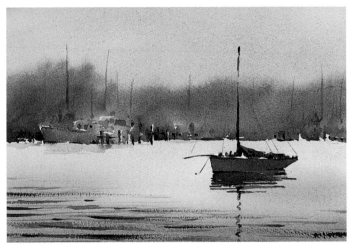

A stiffer, dark mix of all the pigments punches light into the scene, and sharpens the focus. Slightly model the foreground water varying the strokes from light to dark and use horizontal brushstrokes. Flick in the rigging quickly using a finely pointed round brush — paint it in, don't draw it!

Exercise Glazing

The Wake, 11 x 15" (28 x 38cm)

Paper 140lb (300 gsm) Rough

Inspiration photo

Here you will glaze the colors successively onto dry paper, creating depth of color as each transparent glaze glows through brilliantly.

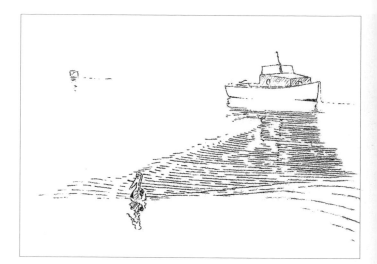

The first step is to draw the scene with an HB pencil. Then apply a small amount of masking fluid to the pelican and the top of the boat so you can apply very wet washes broadly and freely without having to worry about dodging around things.

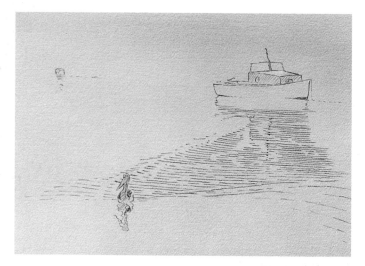

After a couple of minutes while you wait for the masking fluid to dry, thoroughly soak the paper on both sides, then lay it flat upon the board. Float on a gradated wash of **Aureolin**, strong at the top, clear at the bottom. Allow this to dry.

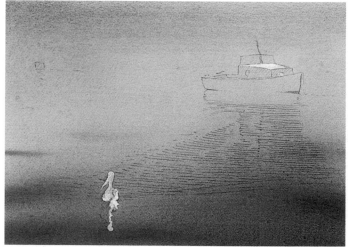

Next, float on a gradated wash of **Cerulean Blue** and **French Ultramarine**, strong at the bottom and clear at the top. While this is still wet, model the foreground movement of the water with stronger mixes of the two blues. Realize that waves have perspective — they appear smaller as they recede into the distance. At this stage thoroughly dry the paper, back and front, using a hairdryer because you will need to remove the masking fluid. If you try this while the paper is damp you will damage the paper surface. Once you've removed the masking fluid, wet the back of the paper and staple the paper to your painting board (tape won't stick to wet paper).

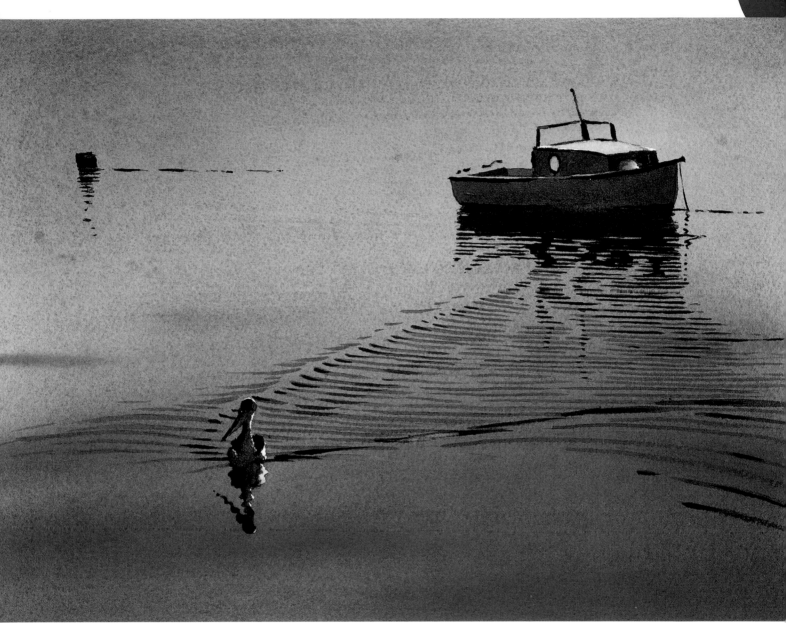

Using various mixes of the four colors, paint the mid-tones.
Then use stiff mixes of **French Ultramarine**, **Alizarin Crimson**
and touch of **Aureolin** to paint in all the dark accents to bring
out the light. A little red accent finishes it off.

Example Planning in action

Hobson's Bay

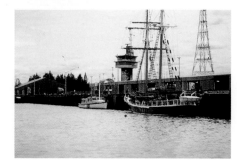 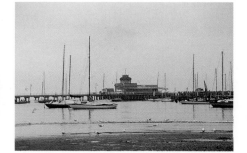

1 Scene photos

You don't have to paint the scene as it is. Here you can see how I rearranged elements from the scene at Hobson's Bay into a compact, expressive painting.

2 Rough sketch
I liked the lines and color of the black and white schooner, and she would be my focal point. The three boats on the left would act as a balancing shape.

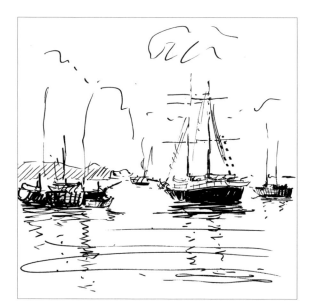

3 Composition drawing
I also like the shape and tonal value of the building on the pier. For balance I introduced the extra boats on the right. The foreground area would be filled with dramatic reflections and counterbalancing horizontal lines.

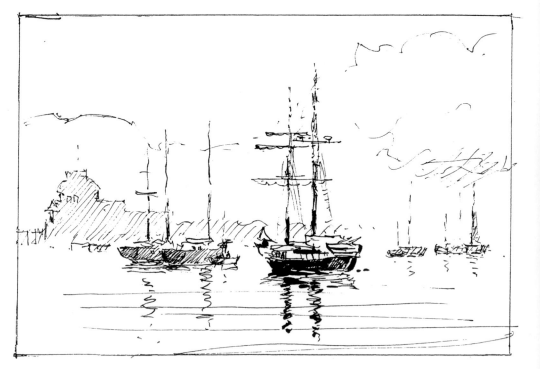

4 **Pen and wash composition sketch**
A simple color sketch developed the idea. By this time I had absorbed the feeling of the subject and knew the mood I wanted.

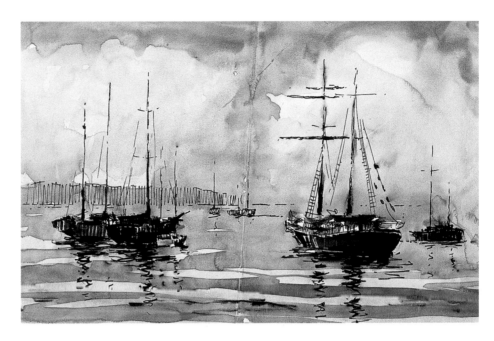

5 **The finished painting**
Many of the techniques you practiced earlier were used in this painting. In particular notice the **variegated wash** in the sky and the **granulated effect**. See how I created the water by painting successive **glazes** on top of **dry washes**. Notice the **tone** of the buildings, the **contrasting** dark tones of the main subject against the light background and the way the boats on the right become a mirage against the beautiful, soft, misty light. **Color** was limited and the orangey masts on the focal ship and the faint warm glow in the distant sky served as **complements** to all the blue. Above all, details are suggested. Examine the **drybrushed** stays, sheets and halyards on the boat rigging. They appear and disappear. Mooring lines serve to anchor the boats in the picture plane and the horizontal waves are a **counterpoint** to the vertical reflections and masts. (By the way, the vertical reflections lead the eye into the scene.) In terms of composition, although the main subject shape is placed centrally, it is **balanced** by the shapes surrounding it.

This painting is a graphic example of how the ingredients of expression can help you paint something that makes an emotional connection with the viewer.

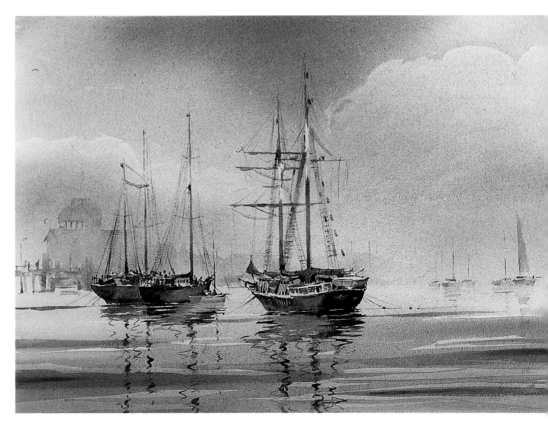

Examples Expression in action

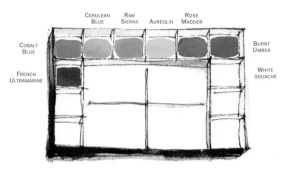

The Endeavour, 11 x 15" (28 x 38cm)

I made this design sketch while sitting in a boat on the water.

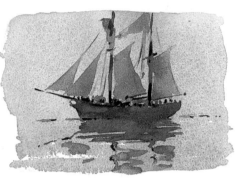

? The Challenge

To achieve an atmospheric impression of a foggy day in Williamstown, Port Phillip Bay, Melbourne. My aim was to paint the "body language" of the boat, giving it character and movement. In order to fulfill my vision, I had to connect the boat to its environment.

Ingredients of Expression

Simplicity
Balance of boat and clouds
Limited color
Soft and hard edges
Limited detail

! Beware

The danger was that the ship would look like a two-dimensional cut-out silhouette.

Viewpoint

Eye-level

 I chose colors that would give a soft, granulated effect.

 I painted the boat and its reflection as a unit to connect it to its environment. There is no dividing line between the hull and the water — the shape of the boat and reflection simply merge together.

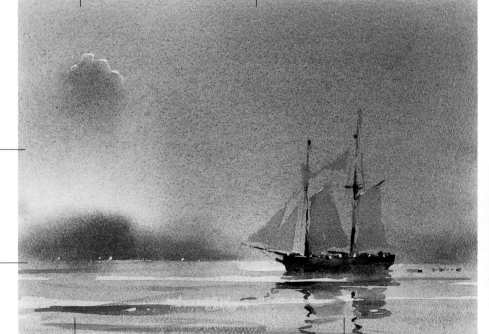

To capture the impression of fog, I painted the scene very wet and without a lot of detail.

Small touches of gouache pick up the dancing light on the boat deck, the spars and sails, the distant shoreline and the highlight on the top of the cloud.

 Notice where I placed the boat in the picture plane, and how it was balanced by the cloud at top left and the suggestion of land on the horizon

 The darkest tones are on the vessel.

The Challenge

The Amalfi Coast was shrouded in haze, with a brilliant, shimmering light coming through the mist. I was attracted by the lone fisherman in his boat. The challenge was to capture the serene atmosphere of the early morning light in the Mediterranean and evoke an emotional response from the viewer. I talk a lot about atmosphere in my paintings, but this is what I look for.

Off Positano, Italy, 22 x 30" (56 x 76cm)

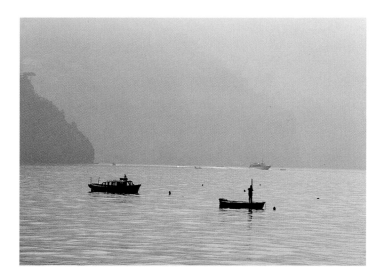

The scene hardly needed rearranging.

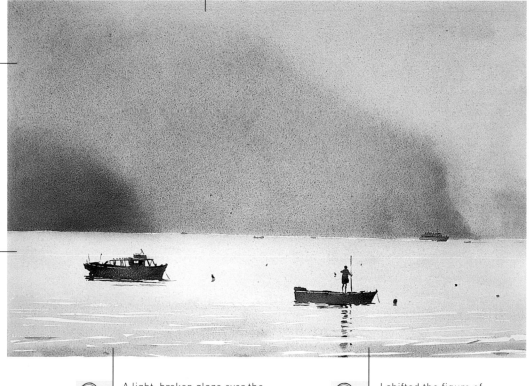

To get this effect I first covered the sheet with a light wash of Raw Sienna. When it was dry, I painted the misty background wet-into-wet to create the indistinct, receding coastline.

You will notice that in the finished painting I moved the distant ferry a little to the right in order to better balance the design.

The initial wash showing through the glazing in the foreground was critical to describe the light on the water.

A light, broken glaze over the foreground described the water, and then the light was punched in with strong, varied darks.

I shifted the figure of the fisherman away from the mast.

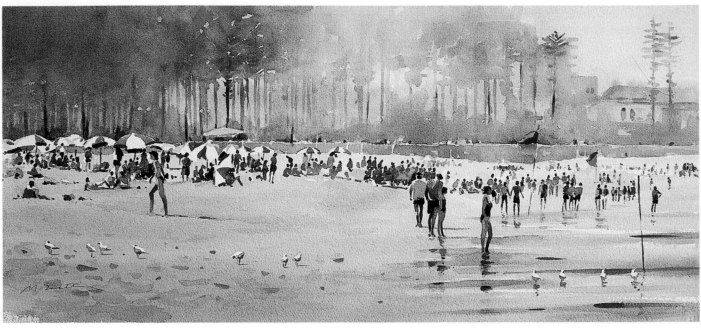

1 Subject selection **2** Design and composition **3** Drawing **4** Tonal value **5** Color

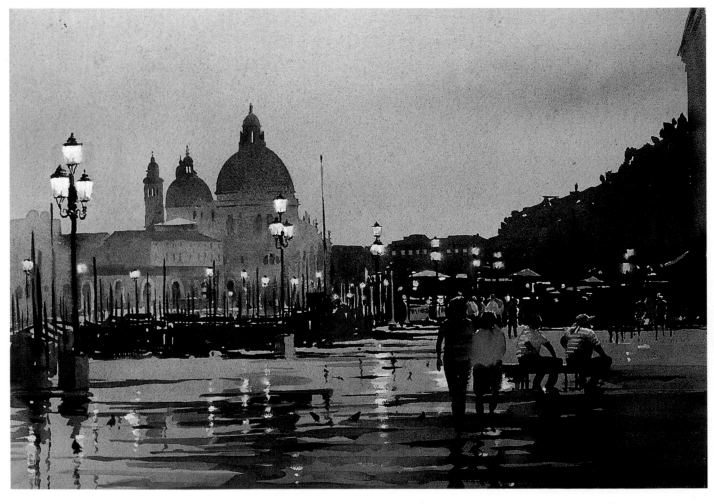

1 Subject selection **2** Design and composition **3** Drawing **4** Tonal value **5** Color

68

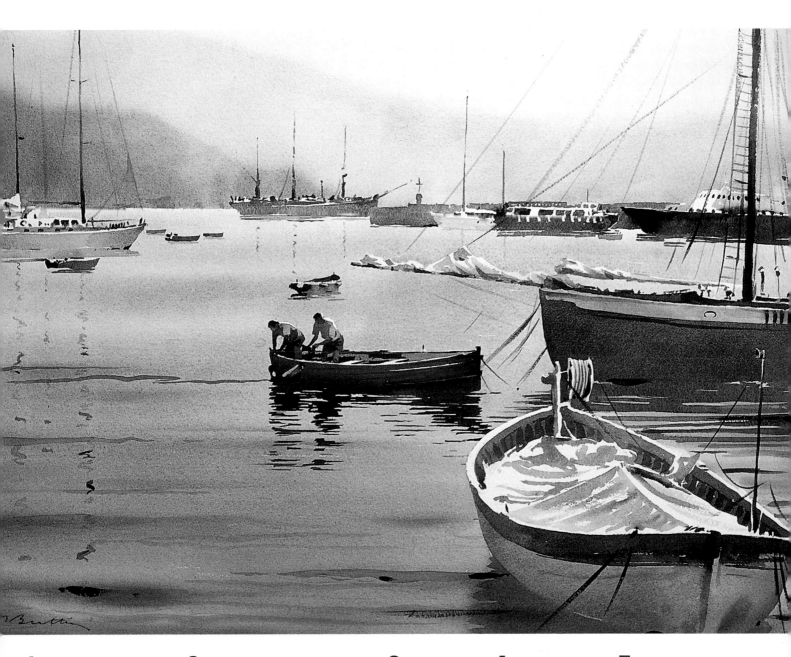

1 Subject selection **2** Design and composition **3** Drawing **4** Tonal value **5** Color

Analyze these paintings to satisfy yourself that all the ingredients of expression are present. Make a list, working through the paintings one at a time, to see what inspires you about each painting.

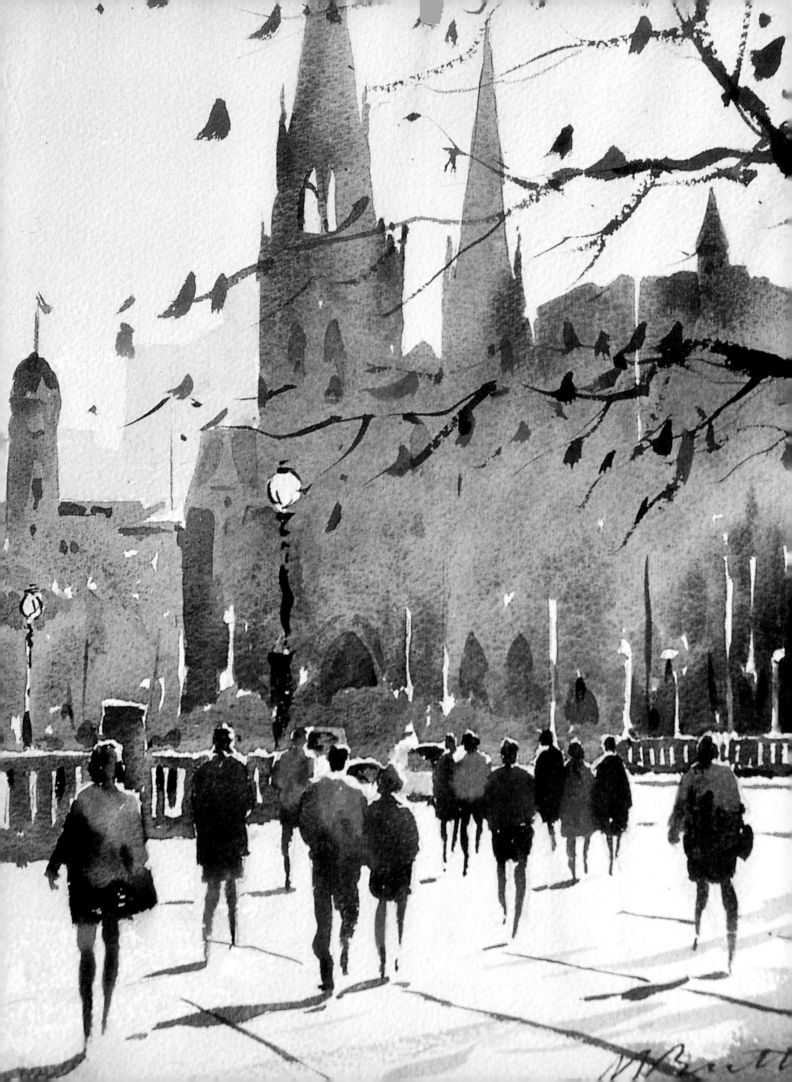

Section 4

Simplifying figures

Here's where you take your art to a new level by mastering a crucial element of the landscape that makes many artists quake. Let me show you how to figure out figures.

Simplifying figures

You can't avoid placing figures in your paintings forever. You can put it off by populating your paintings with cows, horses, sheep, sailing boat, roads, houses, anything that allows you to dodge the dreaded task of painting PEOPLE, but in the end you will come to realize that figures are an integral part of our environment and including them in a painting can have many benefits:

- **Figures can add interest to an otherwise dull or mundane landscape.**
- **They can invoke atmosphere or mood.**
- **They can provide focus, or they can be used to direct the viewer's eye around the painting.**
- **Figures can also provide a connection between the viewer and the painting.**
- **Figures can tell a story or say something about the objects around them.**

However, once you decide to place figures in your paintings you leave yourself open to critical scrutiny from everyone, artists and non-artists. The problem is that everyone instinctively knows when the rendering of a figure is right or wrong.

When you are painting figures you must observe carefully, and practice, practice, practice.

The important points to remember are that figures must be in harmony with their environment, that is, they must be well placed and believable, and they must be painted simply and directly.

In this section I give you a few pointers that may help make your figures believable.

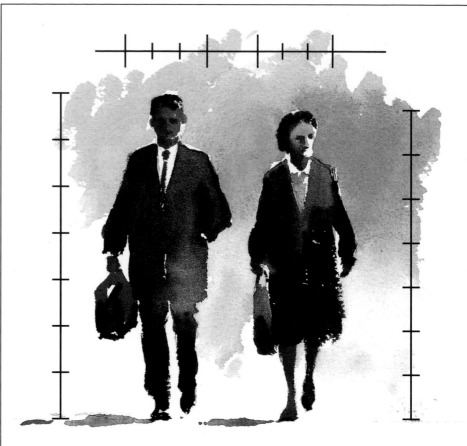

Proportions of the figure

Try to achieve reasonable proportion so that the figures are believable.

The proportions of an adult figure shown here are a general guide only. Every individual is different. Keep these guides in mind, but base your figure painting on careful observation.

Balance

Whether stationary or in motion, the figure should have grace, vitality and balance.

Checklist

- The head goes approximately seven times into the total height of the figure.

- The head is approximately one-third the width of the figure at the shoulders.

- The legs (at the waist) are approximately half the total height of the figure.

- With the arm hanging freely, the bottom of the hand comes about half way down the thigh.

I suggest that you treat these guidelines as a checklist only, and not as a formula. If your figures look odd, run through the checklist to find out what could be wrong — but always paint figures from observation!

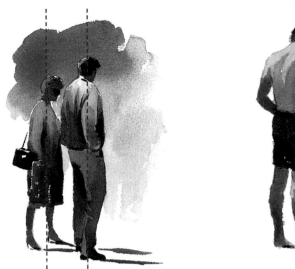
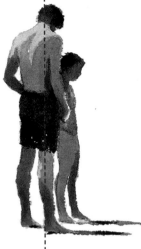

Stationary figures

Notice how the weight of the individual figure is approximately evenly distributed each side of a vertical line from the nape of the neck through the point of balance at the feet.

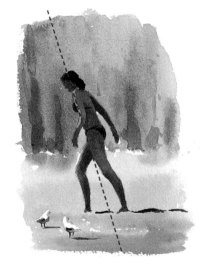
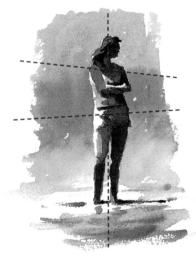

Movement

Even when the figure is engaged in some activity, and therefore off balance, it should have grace in its movement. Avoid painting stick figures. As always, observe carefully and try to capture the **body language** (attitude, posture).

Body dynamics

We all have natural grace, and this is evident when we are at rest. See how the angle of the shoulders is balanced by the opposing angle at the hips.

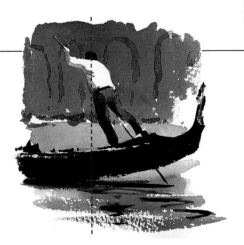

Figures in action

Here, the weight of the figure is unevenly distributed around the vertical line, giving a sense of motion.

If we draw a line from the nape of the neck to the approximate point of balance, this line will give an indication of just how much movement is involved.

Grouping figures

Notice the variation in both the size and position of the positive and negative shapes. Variety is the key.

Right

When placing multiple figures in a painting, vary the shape, size, tonal values and colors of the figures. However, this variety must be achieved with a view to overall harmony — everything must work within acceptable limits.

- Vary the size, shape, position and tone (negative and positive shapes) of your figures. Make them short, tall, skinny, stout, pale, massed shapes and individual figures.

Positive spacing

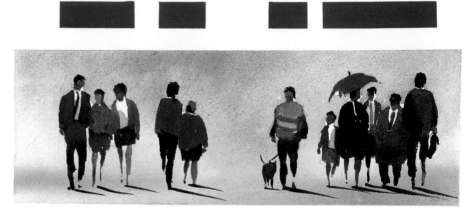

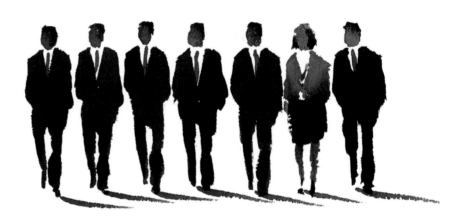

Negative spacing

Wrong! Boring!!!

This group of nearly identical figures, evenly positioned in a group is boring when compared with the previous example,

In all cases, be aware of the proportion of the figures, simplify and strive for movement and interest. Nature is infinite in her variety, so try to avoid repetition.

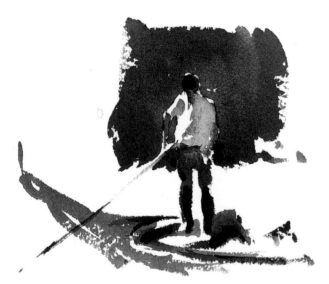

Light

It is difficult to portray light without darks.

Figures are solid — it is the manner in which light falls on them that gives them their form, movement and individuality.

In this example, I have contrasted the light on the figure against a darker background. This is called **counterchange**. Notice how I have painted the gondolier's white shirt a gray color. It is the white retained paper and the overall contrast with the darker background that gives the impression that the shirt is white.

Scale

Be aware of the scale, or size, of the figures relative to their surroundings.

Correctly scaled figures can highlight the grandeur or vastness of a scene. They should always be referenced to their surroundings, with relative measurements observed and noted. Measure the figures against the height of doors, windows, cars, trees, buildings, other people, and so on.

The viewer may be familiar with all or some of these vehicles, and therefore know their size, but once you introduce figures, the viewer does not need to be familiar with them, because the figures will describe the size of the various vehicles very accurately.

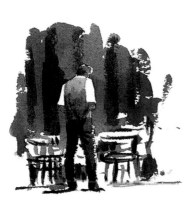

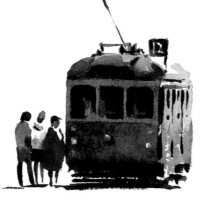

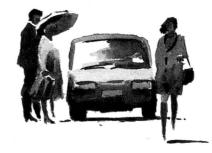

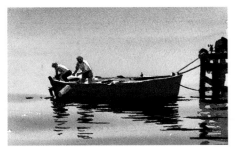

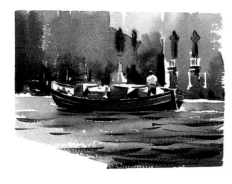

Notice how the size and placement of the figures relate to the doors, windows and the horizon line.

Figures add interest — they suggest an activity, reinforce mood and give scale.

The grandeur and serenity of San Giovanni is reinforced by the placement and attitude of the figures.

Perspective of figures in the landscape

Be aware of perspective, but keep it simple.

The easiest rule of perspective to remember is that figures appear to get smaller as they get further away from the viewer. They also become less detailed and softer in tone and color.

The following diagrams illustrate how to place figures in a painting so that they do not appear to float above the ground

The line of sight always coincides with the horizon line.

Standing view

Generally, when you look at a group of people of similar height on flat ground their heads will all appear on about the same level:

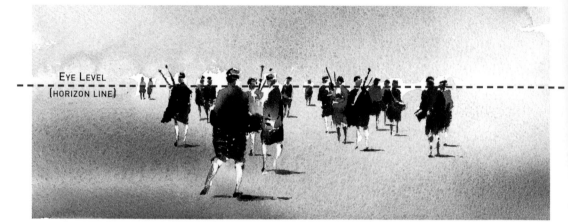

Seated view

If you looked at the same group of people while sitting, this is the perspective you would see:

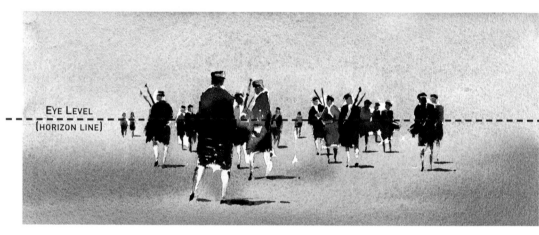

Worm's eye view

Viewed from ground level the perspective would look something like this:

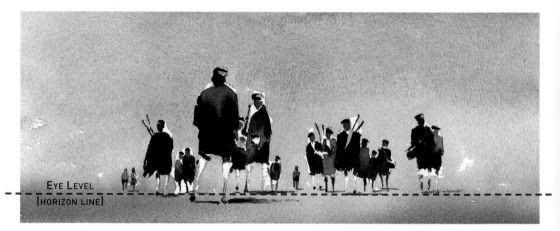

Telling a story

We can use figures in our paintings to tell a story, or to let the viewer read their own story into a scene.

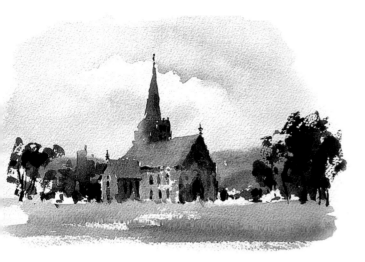

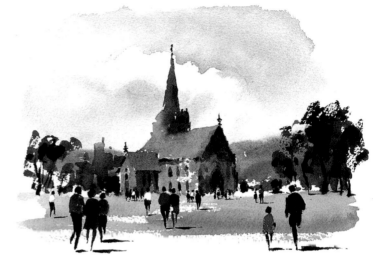

In this painting, it is nice and peaceful — a church in a rural setting. No more, no less.

The figures add value to the original painting, causing the viewer to linger over it as they read its story. The painting now evokes an emotional response from the viewer.

Add some figures, and what do we have?

- The church is large, perhaps a cathedral.
- It is therefore probably in, or near to, a large town or city.
- It could be a Sunday.
- The sun is shining.
- The people are on their way to church for a service, a town meeting, a concert . . .
- There are family groups and individuals.

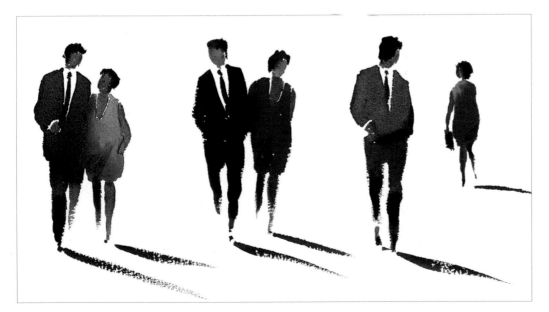

In this simple sketch of figures, there is a lot of body language going on.

- Some are together, and some are not.
- Some are in deep conversation.
- Two are together, but not communicating.
- What's going on with the two individual figures?

Again, figures create interest and cause the viewer to think about the painting. Hint! While they are thinking about your painting, they are unlikely to be thinking about anyone else's painting!

How to paint figures

Paint figures the same way you would paint anything — start with the light tones, introduce the mid tones and accentuate with the dark tones.

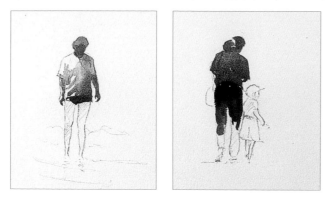

1 First draw an accurate, but not detailed figure with an HB pencil. Then paint from the top of the head down. Here I used a mini beaded, variegated wash.

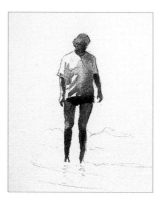 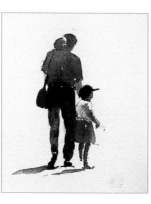

2 Continue down until the mini variegated wash broadly describes the figure.

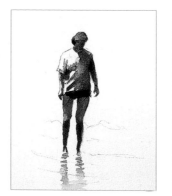 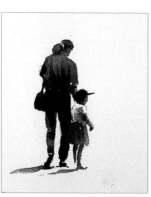

3 Sharpen up the detail, observing the relationship of all the values from light to dark.

Important Notes

- Mass shapes, and generally avoid detail.
- Look for the broad statement and try to capture body language.
- Paint with a brush fully loaded with rich pigment and allow the colors to merge.
- Be acutely aware of the play of light upon the figure.

The usual process is to paint the background first and pop in the figures later. Here, I reversed the procedure to demonstrate how to paint a figure, not a landscape.

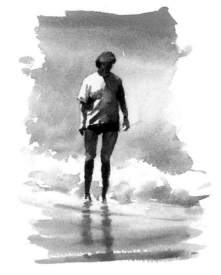

4 Drop in a background to complete the picture.

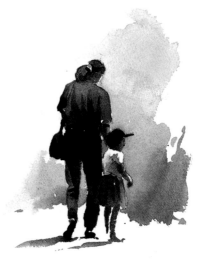

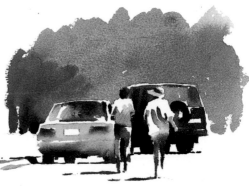

Background figures

Although this is only a small brief sketch, the figures have movement and vitality. I treat small paintings just as seriously as large projects.

Take away the figures, and you may have a nicely rendered painting of a couple of cars — but it would be pretty uninteresting. **Add the figures and WOW!**

Putting it all together

For this imaginary scene, I gradually built the elements a bit at a time, relating one thing to another so that when completed it will suggest a story, an activity or a moment in time.

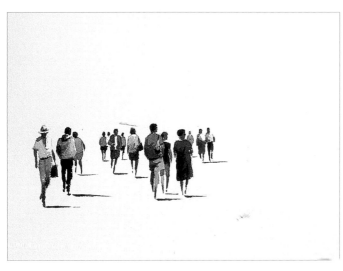

Starting with people walking . . .

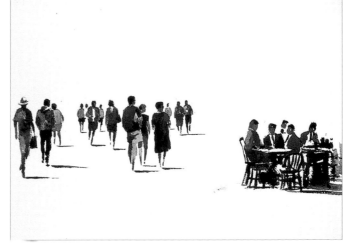

introducing the seated figures . . .

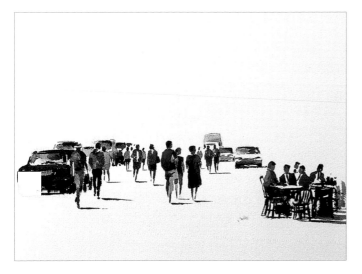

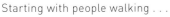

adding cars . . .

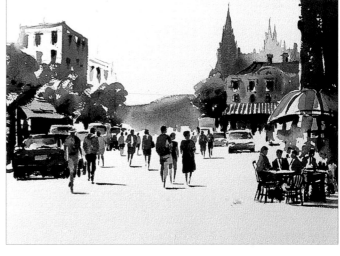

developing the background . . .

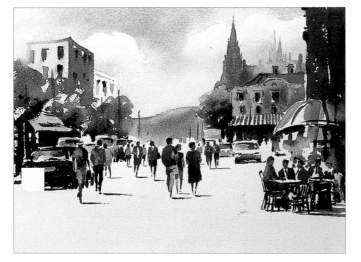

painting the sky . . .

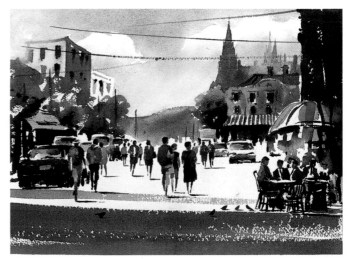

and finishing with the foreground.

79

Observation

As with painting any subject, careful observation is paramount.

Once you understand and absorb what it is you are looking at, the translation to paper or canvas becomes easier. So observe figures wherever you can, note their size, shape, proportion, scale, perspective, tone, color and the effect of light.

doodles

I fill up sheets with doodles such as these. They are great fun to do, and make fabulous reference material. **Most of all, practice makes perfect!**

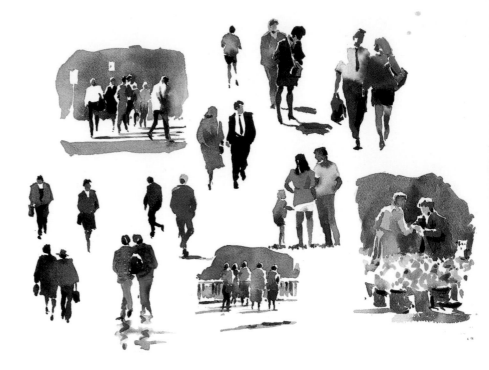

Figure painting can be dealt with at various levels

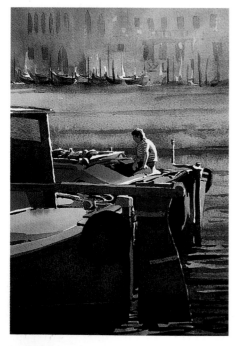

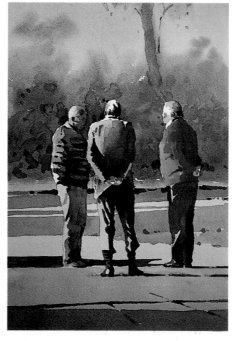

Level 1

Here the landscape dominates, and the figure adds value to it.

There is little figure detail, it was quickly executed, and is only body language.

Level 2

Here the figures are the dominant theme, and the landscape (or background) supports the figures. There is more definition to the figures, with a suggestion of hands and feet but there's still reliance on body language and the way the light falls.

Level 3

At this level the figure is the only theme, that is, it's a portrait. While body language and how the light falls is still paramount, we now allow a degree of detail such as facial features, hands, feet and fingers.

How figures can change the scene dynamics

These small sketches demonstrate the way in which figures can change your approach to painting the same scene.

Version 1

While being a fairly loose interpretation of the scene, this painting is close in terms of light, shade and color. While attention is focused on the dominant foreground tree, emphasizing the strong sunlight playing on the trunk, the sailboats in the distance help the eye travel into the painting.

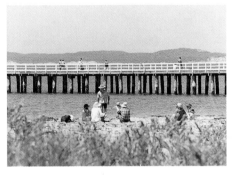

Version 2

Here, I borrowed a couple of figures from another beach and deposited them beside the foreground tree. Instinctively, I was able to soften the whole painting and discard the distant sailboats, because the figures provide a naturally strong focus. This painting now tells a different story. Here it is about the couple on the beach — are they picnicking, chatting, deep in conversation?

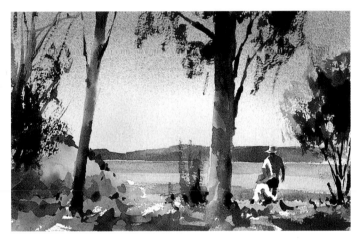

Verdict

The first story is less interesting — it's a yacht race, but that's it. However, in the second one the figures had to be carefully placed, off center and counterchanged against the distant hills so they would be clearly visible.

This was composed of successive glazes on damp paper. It evokes the stillness and calm of a quiet Sunday morning. It was a demonstration painting of clouds — hence the emphasis on the sky.

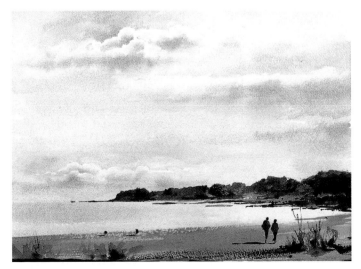

However, the addition of the couple walking their dogs on the beach enhances the mood and gives the painting meaning — it immediately connects with the viewer, telling a story. This is a Level 1 painting.

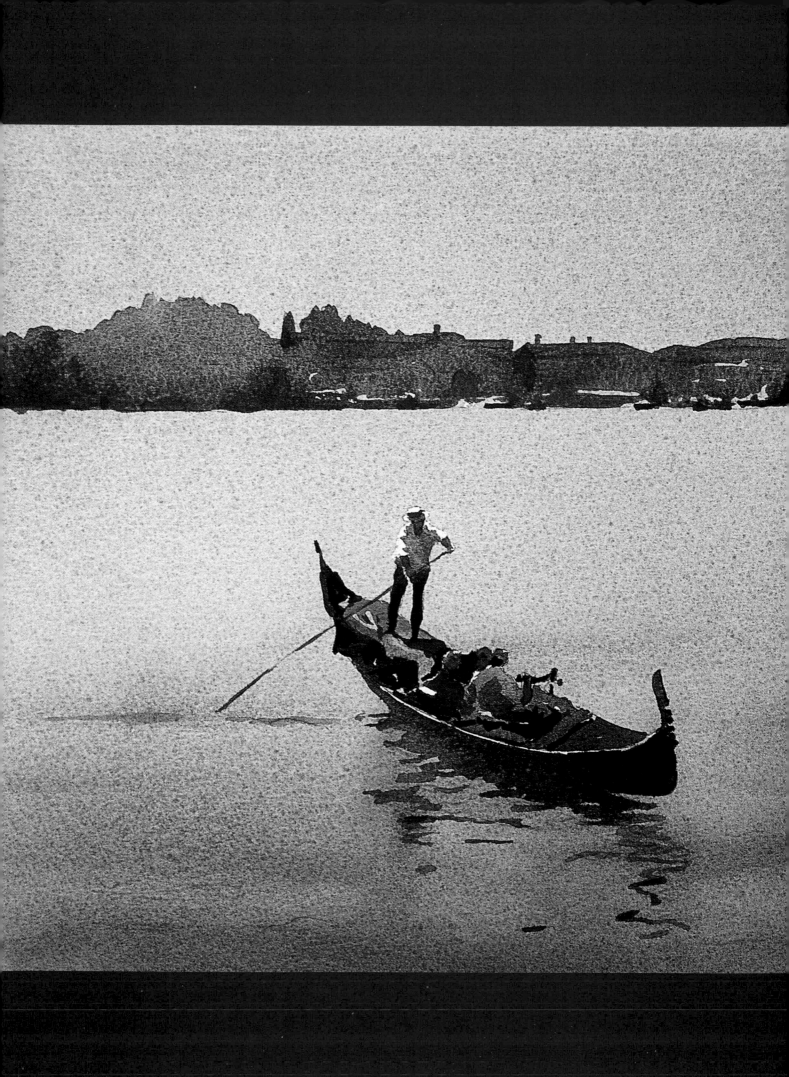

Section 5

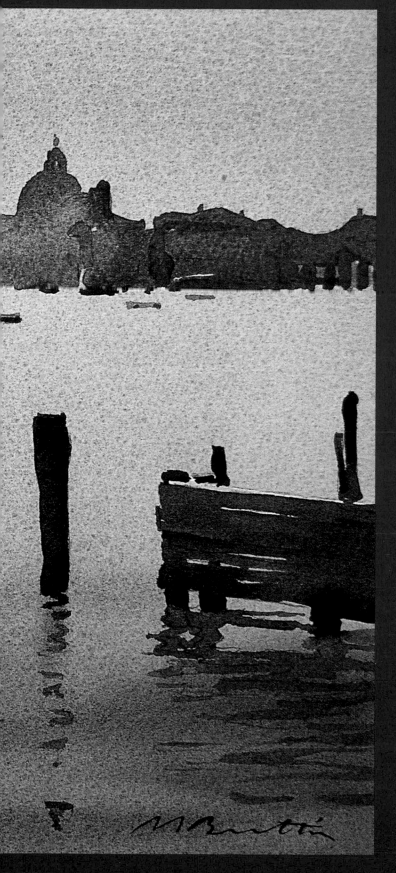

Simplifying in action — The projects

Project 1
Starting with a simple, clean variegated wash

Seagull

Reference Photos
Photographs help you to study the form and shapes, the way the light falls. Look for character and movement. Do lots of pen and wash and pencil sketch character studies.

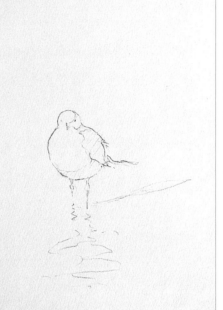

1 For such a clear statement, simplicity is the key. The tonal values must be strong, and the washes clean. Make some practice sketches of seagulls to get you in the swing of it.

2 Sketch the seagull simply with an HB pencil. Place the bird slightly off-center, high enough on the paper to cater for the reflection in the wet sand, but with enough space around it to describe its environment. Draw an absolute minimum of detail —just enough to describe the form of the bird, its reflection and the direction of light. Try to complete the drawing without erasing because this can damage the paper. When you have finished, tape the paper firmly to a painting board.

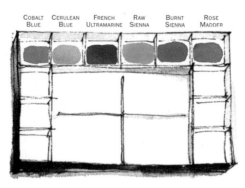

The Challenge

To lay a clean, transparent, variegated wash that sets the scene for simple, straightforward expression of serenity

Design

The colors will be repeated throughout the painting in order to create color harmony

Techniques you will use

The controlled wash method of painting, building tones and definition at each stage
Limited palette
Variegated washes
Counterchange — tonal values
Reserving white paper
Modeling shapes

Viewpoint

Looking down

Angle of Light →

Sun low in the sky, long shadow

Expression

The simplicity of the scene and the peaceful feeling that it inspires

What you will need

COBALT BLUE CERULEAN BLUE FRENCH ULTRAMARINE RAW SIENNA BURNT SIENNA ROSE MADDER

Paper
140lb (300gsm) Rough
11 x 8" (28 x 20cm)

Brushes
Wash brush #8,
Round synthetic, #12, #8 and #4

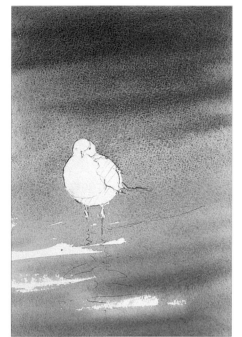
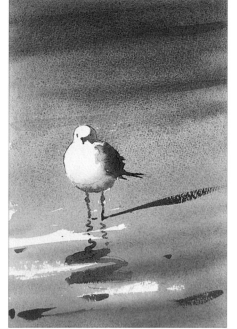
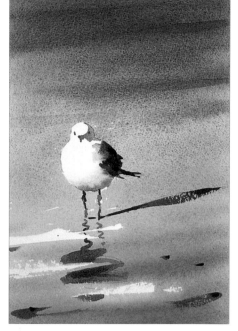

3 With the board at a slight incline, load your brush with **Cobalt Blue** and lay a very wet wash from the top down. Avoid painting over the seagull. Quickly brush in a very wet wash of **Raw Sienna**, making sure the two colors blend seamlessly — manipulate the board so that gravity does the blending. You should not be able to see where one color stops and the other starts. Leave a little white paper in the foreground to provide sparkle and balance to the seagull. While the wash retains its shine, model the background with a deep mix of **French Ultramarine** and **Cerulean Blue**, and the foreground with a strong mix of **Burnt Sienna** and **Rose Madder**. Lay the board flat and allow the painting to dry thoroughly.

4 Model the gull with mauve (**Cobalt Blue** and **Rose Madder**) ensuring the shading of the bird describes the roundness of its form. Soften edges here and there and allow the orange of its beak to blend with the mauve modeling. Quickly add the reflection (mauve), the cast shadow and the foreground accents (**Burnt Sienna**) using quick, drybrush strokes. Subtly suggest wave motion in the background using **French Ultramarine**. Dry with your hairdryer.

5 Use **French Ultramarine** and **Burnt Sienna** to provide the dark accents that sharpen the focus and accentuate the light. Do not overdo these accents — a little goes a long way.

Critique
A very simple, yet effective painting. The limited palette reinforces the simplicity of the scene. I think the bird is cheeky — it has character.

Exercise

If you would like a challenge, try painting a flock of seagulls — the technique is basically the same. Here are a few of mine done on a half-sheet of watercolor paper (15 x 23"). Note that each bird is an individual, they are not placed mechanically, and their placement gives the painting depth.

HINT — Pre-wet the paper, going around the birds, then float on the colors.

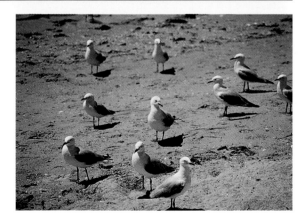

85

The Challenge

To create a soft, light filled painting, and to capture the personality of the geese

Design

Simple abstract shapes carefully placed

Techniques you will use

Working on damp paper (towel dry)
Limited palette
Variegated washes
Glazing wet-in-wet
Glazing wet-on-dry
Reserving white paper
Painting short
Counterchange (contrast)
Directional brushstrokes

Viewpoint

Looking down

Angle of Light

Shining on the geese from top right

Expression

The alert, "on their toes", nature of the geese and their lovely, rounded shapes. The soft, misty nature of the background

Project 2
Working with easy abstract shapes

En Guarde

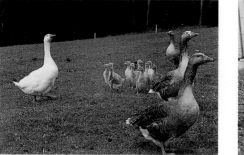

Study these photos and get a sense of the form and character of the geese.

Design sketch
Notice the overlapping shapes, the varied horizon line, how the direction of light has been set and the abstract shapes in the foreground grass.

Color sketch
Get in the habit of making color sketches.

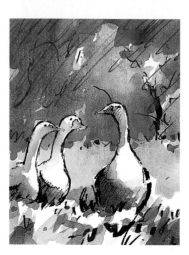

1 Draw the design with an HB pencil. The drawing is your roadmap, it takes you from your starting point and guides you to the destination, describing only those details essential to the journey. Once the drawing is completed, immerse the paper in water until it goes limp, lay it on a painting board and carefully towel-dry the surface. **Press the towel — do not scrub it, or you will damage the paper.** This procedure also ensures that the paper lies flat on the painting board. You will not need to tape the paper.

What you will need

CERULEAN BLUE FRENCH ULTRAMARINE NAPLES YELLOW ROSE MADDER BURNT SIENNA CADMIUM RED

Paper
140lb (300gsm) Rough
15 x 11" (38 x 28cm)

Brushes
Wash brush #8, Round synthetic, #12, #8 and #4

2 Glazing complementary colors wet-in-wet suggests movement. Vary the edges on the horizon line from soft to hard. Use directional brushstrokes for the foreground grass. With the board at a slight angle to the horizontal, use a medium wash brush to float in **Naples Yellow** to the background, cut around the geese and finish off at the base of the geese with jagged brushstrokes that suggests grass shapes. While that's wet drop in **Cerulean Blue** behind the geese to develop the soft form of the trees and the undergrowth in the background. Strengthen these shapes with a little **Burnt Sienna** and **French Ultramarine**. Using the same colors suggest the foreground, then paint the form of the geese so that their edges merge gently with the background.

Dry the paper until the front is dry but the back of the paper is still wet. This ensures that the paper will still stick to the board. As well, washes applied to this surface will stay wet and workable for an extended period.

3 Paint short to allow flicks of the first wash to show through. Develop the background detail but keep it soft and abstract. Mix **Cerulean Blue** and **Naples Yellow** in the palette and glaze over the background. Vary the mix and leave gaps to simulate light flickering through the trees. Develop the rounded form of the geese with varied mixes of **Cerulean Blue**, **Burnt Sienna** and mauve **(Cerulean Blue + Rose Madder)**, and paint the beaks with orange **(Cadmium Red + Aureolin)**, allowing the colors to drift. While the background is still wet, drop in mauve highlights and accent the tree branches. Model the foreground with mixes of the background colors, keeping everything simple and abstract. Dry as before.

4 Make sure the geese are well-rounded. Maintain contrast between the geese and the background so that there are areas of light/dark and dark/light. Keep the foreground shapes simple and abstract. When you add the accents to sharpen the focus and accentuate the light DO NOT OVERDO IT! All you need to do now is to sharpen up the image, mostly the geese, so that they stand out from the background. Use **French Ultramarine** and **Burnt Sienna**.

Critique
The washes and glazes are clean. There is a feeling of light coming through the painting. At least one of the geese has attitude. They stand well forward of the background.

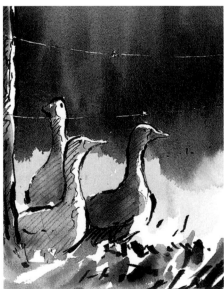

Exercise
Use this pen and wash study as a basis for another painting. This sketch has a strong, dark background to emphasize the light on the geese.

Project 3
Breathing life into a dark background

Fowl Business

 The Challenge

To capture the personality of the chickens, and to breathe some light and interest into the background without detracting from the birds

 Design

A definite focal point

Techniques you will use

Wet-on-dry paper
Wet-in-wet
Reserving white paper
Variegated washes
Painting short
Counterchange (contrast)
Directional brushstrokes

 Viewpoint

Looking down

Angle of Light ↓

Directly overhead

★ **Expression**

The wonderful posturing personality of the hens — alert and leggy

! **Beware**

Take care to retain white paper for the major shapes (the chickens) and where sunlight hits the objects

Here are your actors. This dark background has to go.

I chose the first photo and simplified it by removing a chicken and adding light to the background to open up the scene and add interest. The window in the back wall of the shed provides a pathway for the eye to travel into the distance. The way the chickens face each other provides a very powerful focal area. The palette chosen reflects the bright, sunny disposition of the chickens

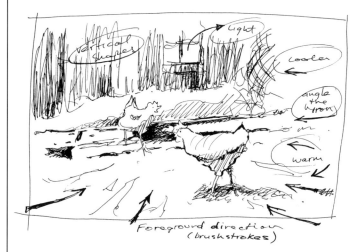

A design plan should simplify everything. Notice how I indicated where the vertical shapes would be, the direction of light, the angle of the barn, where the warm colors should go and where the cooler colors should go — remember, warm colors come forward and cool colors recede. You can even mark the foreground direction of brushstrokes. The rear chicken connects the background to the foreground. The window gives the illusion of depth.

What you will need

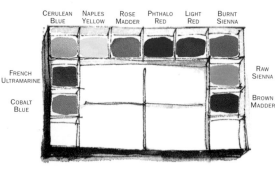

CERULEAN BLUE NAPLES YELLOW ROSE MADDER PHTHALO RED LIGHT RED BURNT SIENNA

FRENCH ULTRAMARINE

COBALT BLUE

RAW SIENNA

BROWN MADDER

Paper
140 lb (300gsm) Rough
11 x 15" (28 x 38cm)

Brushes
Wash brush #8, Round synthetic, #12, #8 and #4

1 Because the linework will be your guide during the course of the painting, it needs to be strong enough to show through the various washes and glazes. Make a relatively detailed drawing which accurately shows the shadow patterns around the chickens,

as well as the shadow on them. Use an HB pencil, but do not press too heavily because you will only bruise the paper. Setting the dividing structure at an angle gives the picture some dynamic tension. Just making it a horizontal line would be boring.

2 Wash in the background with a variegated wash of **Raw Sienna** and **Cerulean Blue**, with the farm junk a mix of **French Ultramarine** and **Brown Madder**. The near wall of the shed and the dividing structure on the ground is **Cobalt**

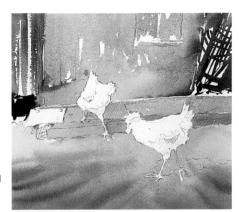

Blue modified with **Raw Sienna**. The foreground is **Raw Sienna**, warmed with **Burnt Sienna** and **Light Red**. Use directional brushstrokes wherever possible. Dry with your hairdryer.

3 Develop the dark interior of the shed with varied mixes of **French Ultramarine** and **Brown Madder**, allowing plenty of the undercolor to come through (paint short). Then, with a light mauve mix of **Cobalt Blue** and **Rose Madder** and a

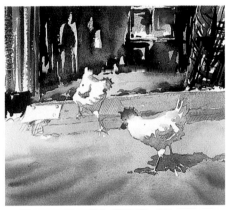

hint of **Raw Sienna**, begin to model the chickens. Make sure you maintain the light on the chickens. Use **Phthalo Red** to state their combs. This is probably enough to handle at this stage. Dry with your hairdryer.

4 Bring up the shadows behind the chickens with **French Ultramarine** and **Brown Madder**, and create interest in the foreground by drifting in a very wet, transparent wash of **Raw Sienna** and **Burnt Sienna**. Keep this foreground abstract and simple.

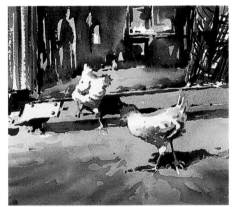

Create strong shadows for contrast to highlight and describe the chickens. Make directional brushstrokes to draw the eye toward the nearer chicken. Drop in a little **Cerulean Blue** while wet, and continue to develop the form of the birds. Do not cover up too much of what has been previously painted — paint short! Dry with hairdryer.

5 Use strong, dark accents to bring the scene into sharp focus and accentuate the light falling on the subject. Use mixtures of **French Ultramarine** and **Brown Madder**, with flicks of **Phthalo Red** and **Cerulean Blue**. Place some cool accents in the warm foreground.

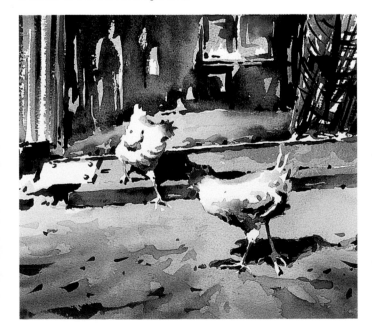

Exercise
See how you can make a painting from this photograph. Hint: Black chickens still have highlights. They also give you the opportunity to include in some great contrast.

Project 4
Making a quick impression

Patio Flowers

Here's where impressionist realism is born. The good news is you don't have to paint everything realistically, particularly if the subject is a complex one like a mass of flowers.

So, instead of copying every flower and leaf, I will show you how to make a quick, loose impression which just suggests flowers. Suggestion is one of the keys to expression in art. I am sure this will be a huge relief to all those people who don't know one flower from the next. Here's how this painting came about.

? **The Challenge**
To paint the "idea" of flowers in a pot

Techniques you will use
Wet-on-dry paper
Wet-in-wet
Hard and soft edges
Wiping out details
Strong finishing accents

1 **Design sketch**. I had just hosed down the patio, and the flowers and pots took my eye — I sketched the scene quickly. The sketch, together with some hurriedly scribbled observations, provided enough information for me to render a quick impression later in my studio.

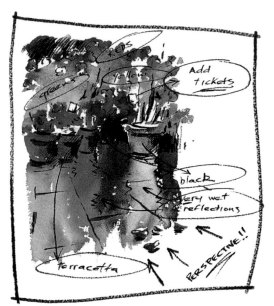

This quick painting suggests "roses" without being a botanical study. How did I do this? Hint! It could have something to do with shape.

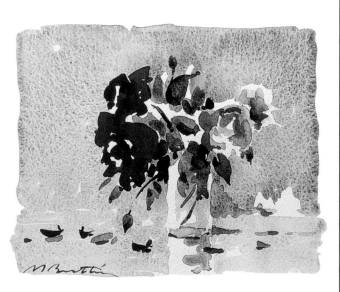

What you will need

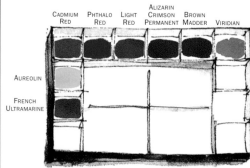

Paper
140 lb (300gsm) Rough
22 x 15" (56 x 38cm)

Brushes
Wash brush #12
Round synthetic #12

Exercise Here's another one for you to try

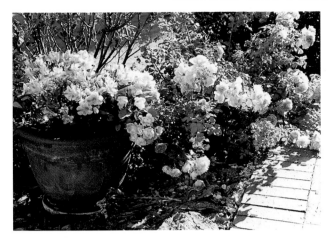

This profusion of flowers and foliage could be a daunting subject.

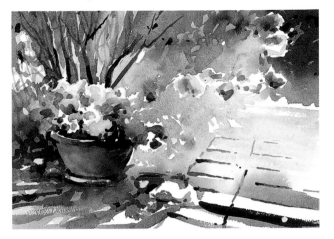

But look what happens when we make a loose impression

The mood in this piece is the morning light and the ethereal quality of the flowers — that's the expression part of painting! The light playing on the flowers contrasted with the deep morning shadows. The thing that attracted me about this scene was the delicate nature of the flowers. Now you have a go.

2 My interpretation. The finished painting proved to be a rather abstract interpretation. One of my students is a florist and when I showed her this painting she had trouble accepting the concept because she could not identify the flowers. This perhaps an example of when too much knowledge of a subject can hinder the creative approach. However, from my point of view, the type of flowers was irrelevant. What I aimed to paint was the soft, transient nature of the scene as a whole, and therefore I did not want to know what sort of flowers they were. This would probably have tightened me up and got in the way of the fluid, very wet, immediate, vigorous approach. The whole painting took about 20 minutes. **Now you have a go!**

Paint the top shapes (the flowers) wet on dry paper. Then model wet-in-wet, with hard edges controlling the shapes and complementing the soft edges.

From the pots down, make your work all wet-in-wet, developing the shapes into the damp paper.

As the paper dries, use a stiffer mix (less water) and place the final accents quickly and very strongly onto not-quite dry paper. Exciting and fun!

Perspective device leads the eye into this part of the painting.

Petals create balance, or tension, to the focal point.

Notice how the hard edges and white paper of the flowers contrast with the wet, blurred foreground.

Tilt the board vertically when you paint the reflections.

Wipe out detail with a damp brush while the paper is still wet.

Pre-wet the paper with directional strokes of the brush so that any flicks of dry paper (sparkle) will support the perspective.

Project 5
Experimenting with hard and soft edges

St Helens — Bursting Wave

Water and clouds are not pure white, they have other colors reflected in them from whatever surrounds them. In the case of waves, naturally there will be blue from the sea and the sky, as well as color from the rocks and beach.

1 After sketching the scene with an HB pencil, soak the paper thoroughly, lay it flat on your board and use a towel to dry the painting surface. Do not tape the paper to your board.

? The Challenge

To capture a wave using a mix of hard and soft edges

Techniques you will use

You will be painting largely wet-into-wet on damp paper to achieve a balance of soft and hard edges.
Wet-in-wet
Reserving white paper
Variegated washes
Painting short
Directional brushstrokes

Viewpoint

Eye level

Angle of Light

Overhead

! Beware

Pay attention to your edges so the water does not look solid

★ Expression

The energy and movement of the sea bursting on the rocks

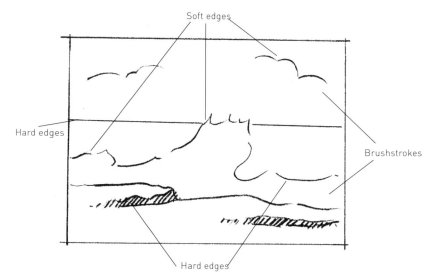

Soft edges

Hard edges

Brushstrokes

Hard edges

Preliminary edge sketch
One of the important design considerations is varying edges between hard and soft. Hard edges give definition, they tend to bring things forward and enhance the focal point. Soft edges suggest distance and they can help play down parts of the painting that are not the focal point. Pay attention to your edges and where possible use a mixture of hard and soft edges in your work.
Above is the edge analysis for this simple scene.

What you will need

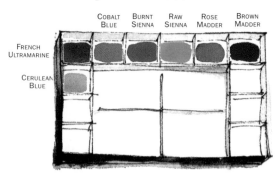

COBALT BLUE BURNT SIENNA RAW SIENNA ROSE MADDER BROWN MADDER

FRENCH ULTRAMARINE

CERULEAN BLUE

Paper
140lb (300gsm) Rough,
8 x 11" (20 x 28cm)

Brushes
Chinese waterbrush,
Wash brush #8,
Round synthetic, #10

Suggest shadows on the underside of the clouds with a gray mix of **French Ultramarine**, **Raw Sienna** and **Rose Madder**.

Leave the breaking wave as white paper with soft, wet-in-wet edges. Below the horizon, dampen the paper around the edges of the waves and wash in the sea with **French Ultramarine** and **Viridian**, making sure the waves have soft edges.

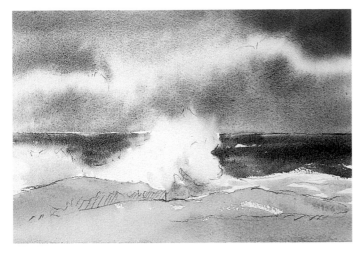

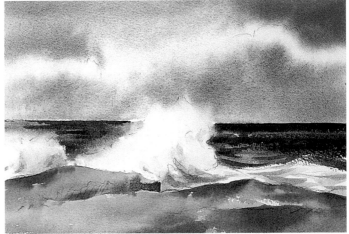

2 With the board at a slight incline to the horizontal, wet down to the horizon line with a large, flat brush and paint the sky and clouds with varied mixes of **Cerulean Blue**, **French Ultramarine** and **Rose Madder**.

Model the wave gently with directional brushstrokes using soft mauve (made from **Cerulean Blue** and **Rose Madder**), **Viridian** and **Raw Sienna**. Lay in a **Raw Sienna** wash for the foreground rocks, warmed up with a little **Burnt Sienna**. Dry the painting surface only. Keep the back of the paper wet.

3 At this stage the idea is to maintain soft edges to create a sea-spray effect. Paint short, leaving areas of the previous wash to show through, creating form, movement and light With a mix of **French Ultramarine** and **Viridian** suggest the form of the sea — but do not make the wave burst hard edged.

Model the movement of the water within the wave with directional brushstrokes, then move onto the rocks, glazing with **Burnt Sienna** and a little **French Ultramarine**.

Add a little of the ocean color to the foreground to suggest wet rocks. This also links the middle distance to the foreground. Dry the painting surface with your hairdryer — keep the back of the paper wet.

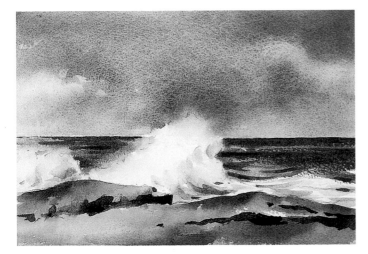

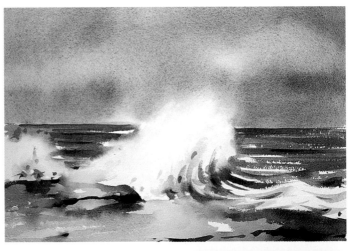

4 Wet the sky area down to the horizon. Go over the wave as well, and float in a very wet glaze of **French Ultramarine** and **Rose Madder** to push the sky and clouds into the background, thus throwing emphasis onto the waves bursting on the rocks. Add slight accents to the wave, water and foreground to sharpen the image. Staple it to the board and allow to dry naturally.

Here's another version of the scene, painted using the same method as the demonstration. In this version I made the sky behind the wave lighter, and the rocks less defined.

Exercise
Now repaint this as a sunset scene and imagine the colors you would see in the wave.

Project 6 Painting the light and its colors

Lake Tyers Reflections

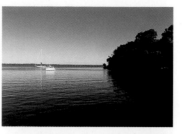

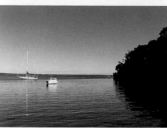

1 Sketch the scene with an HB pencil and then tape the paper firmly to a lightweight painting board. Remember, sketch briefly but accurately.

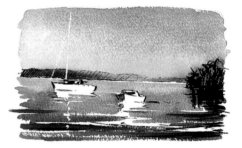

Occasionally a scene will present itself that needs little or no editing and there's nothing to add, shift, delete or alter in any way. However, it will still need simplifying — that is **suggesting, rather than recording, detail**.

Thus, the painting becomes our interpretation of the scene.

We should strive for an emotional response by painting the mood or atmosphere — the effect of light playing upon the scene before us. Look carefully at any scene and analyze the light. Ask these three questions

- **Which direction does the light come from?**
- **Is the light cold or warm color temperature?**
- **What are the underlying colors that describe the light?**

Don't just copy. Analyze, interpret and then work towards your interpretation. **But above all — simplify!**

The design
The eye will travel between the main elements of the painting — the land mass and the two boats. You will see in this pen and wash color sketch that I moved the landmass closer to the boats to make the scene more intimate — to bring the subjects closer to the viewer. In this case the boats do not overlap. Normally, if there were many boats in a painting, you would look for and utilize overlapping as a way of creating interest and linking objects throughout the painting.

In this project we are looking for devices that help describe the light and sparkle on the water.

The painting will mostly be done with the board raised at a slight angle of about 5-10° to the horizontal. Do as I do and rest the board on a roll of masking tape laying flat on the table. See the picture of me at the top of this page.

What you will need

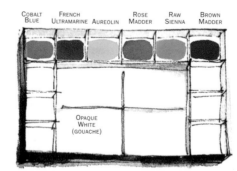

Paper
140 lb (300gsm) Rough,
7 x 10" (18 x 25cm)

Brushes
Large water brush
Wash brush #8,
Round synthetic, #12, #8

The Challenge
To use a technique that will capture the absolute serenity of the place, and the way the colors reflect throughout the scene

Design
The scene is simple and unfussed — it will be important to maintain this simplicity

Techniques you will use
The controlled wash method
Glazing transparent washes
Building the tonal values
Defining of the subject gradually at each step
Limited palette
Variegated washes
Wet-in-wet
Wet-on-dry
Counterchange — tonal values
Reserving white paper

Beware
The washes will need to be open and clean, with the boats stated simply

Viewpoint
Eye level

Angle of Light
High in the sky, top right

Expression
The light and tranquility of a clear summer day

Gradated wash

Colors merge
seamlessly

Paint short to describe the
boat reflections and the light
reflecting off the water. Warm/cool contrast

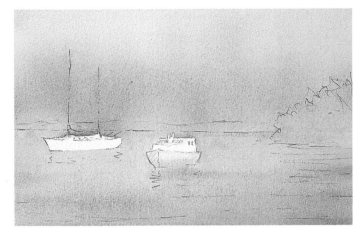

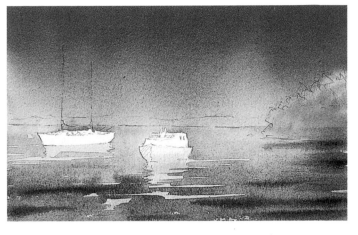

Wet-in-wet modeling Gradated wash

Quick drybrush stroke Warm/cool contrast

2 Wet the sky, drop in **Rose Madder**, gradated from the horizon up. Then lay a wash of **Raw Sienna** in the water area, skirting around the boats, allowing the **Rose Madder** to merge down into the **Raw Sienna**. Add a little **Rose Madder** to the foreground **Raw Sienna** while still wet. Let the painting dry thoroughly. Use your hairdryer if you are in a hurry — otherwise have a coffee and relax.

3 Quickly wet the sky with clean water, and apply a strong, gradated wash of **Cobalt Blue**, lighter towards the horizon, and continue into the water, leaving the boats and their reflections. Strengthen the wash towards the foreground. Model the foreground with mixes of **Cobalt Blue** and **Raw Sienna**, and **French Ultramarine** and **Raw Sienna**. Drop in a little bright green (made from **Cobalt Blue** and **Aureolin**) to the land mass area while still wet. Dry as before.

Varied tones and color

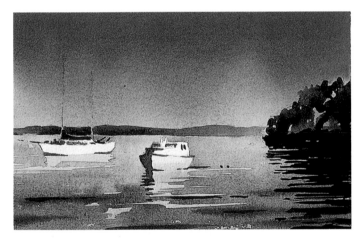

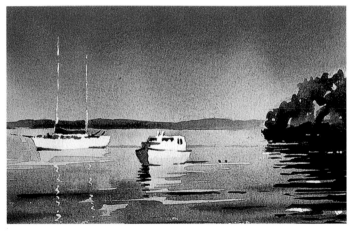

The reflections in the water approximately mirror
the shapes of the boats

Tonal extremes —
dark against light

Tonal extremes —
light against dark

4 Paint the distant shoreline **Cobalt Blue** and **Raw Sienna**, varying the tonal values, and the land mass with a varied mix of **French Ultramarine**, **Raw Sienna** and **Brown Madder**. Suggest the reflections with the same mix. Pick out the boats with "grayed" mauves and touches of primary colors for their details. Do some modeling to the foreground water, but not too much, because we want to retain the feeling of calm water. Dry with your hairdryer.

5 The finishing touches. The darkest dark (**French Ultramarine** and **Brown Madder**) brings the scene into focus. Similarly, use **white gouache** for the boat masts (pure white), and reflections. Dash in a few off-white accents of **white gouache** and **Raw Sienna** into the foreground. The extreme tonal value of the accents punches light into the painting by providing strong contrasts with the adjacent values. **Do not over paint**. Dry. Remove the tape and assess the result critically.

> **IMPORTANT NOTE**
> The sparkle in the water is achieved by preserving areas of the initial warm wash, providing both tonal contrast and contrast of (complementary) color.

Project 7 Figures on a beach

A Stroll On The Beach

1 Draw the scene with an HB pencil. It is important at this stage to draw the figures accurately and convincingly. This doesn't mean a lot of detail such as hands and feet and features, just capture enough of their attitude and grace so that your picture suggests them strolling along the beach, deep in conversation. Body language! You will be working on damp untaped paper.

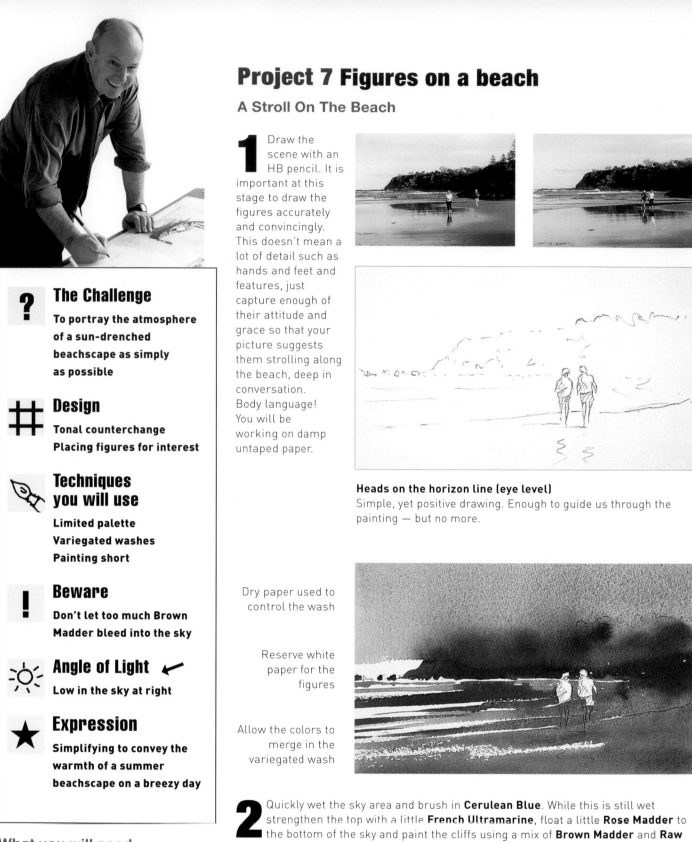

Heads on the horizon line (eye level)
Simple, yet positive drawing. Enough to guide us through the painting — but no more.

Dry paper used to control the wash

Reserve white paper for the figures

Allow the colors to merge in the variegated wash

2 Quickly wet the sky area and brush in **Cerulean Blue**. While this is still wet strengthen the top with a little **French Ultramarine**, float a little **Rose Madder** to the bottom of the sky and paint the cliffs using a mix of **Brown Madder** and **Raw Sienna** (make sure your brush is not too wet or the color will bleed too much). Leave a puddle (bead) at the base of the cliffs, and with **Cerulean Blue** modified with a little **Cobalt Blue** paint the water, taking care to avoid the figures. Now pick up the puddle from the hills and draw it into the foreground with **Raw Sienna**. Warm the immediate foreground with a little **Brown Madder** and **Rose Madder**. This whole process should be done quickly with attention paid to the placement and reservation of the white paper. Once you've done this most of the color in the painting will be established. Dry with your hairdryer.

What you will need

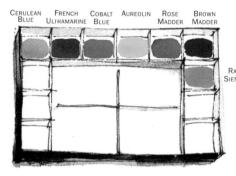

CERULEAN BLUE FRENCH ULTRAMARINE COBALT BLUE AUREOLIN ROSE MADDER BROWN MADDER

RAW SIENNA

Paper
140 lb (300gsm) Rough,
7 x 11" (18 x 28cm)

Brushes
Round synthetic, #12, #8 and #6

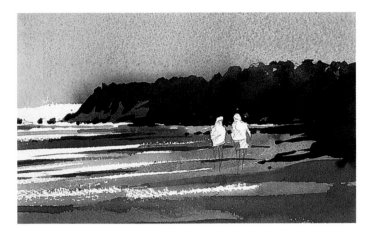

Develop form in the
water and foreground.

Paint short.

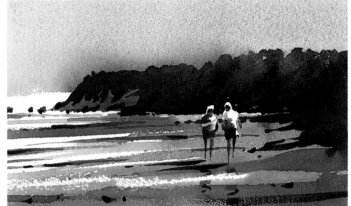

Maintain consistency in the direction
of light on the figures and the
shadows cast on the ground.

Paint figures
with strong color.

3 Lay in a strong, wet mix of **Brown Madder** and **French Ultramarine** for the hills, dropping in a strong green (**Cobalt Blue** and **Aureolin**) here and there for variation and to suggest vegetation. Work this deep color into the foreground and then model the water and beach with local color.

4 Paint the figures paying careful attention to the direction of the light. Paint them loosely to suggest movement. Use the drawing as your guide. Start at the top of each figure and proceed down, allowing the colors to merge. Make sure that their heads are contrasted against the dark of the distant cliff — this strong tonal counterchange will draw the eye irresistibly to the figures.

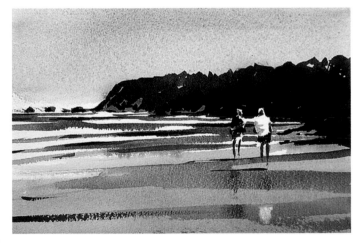

Another version

This time I wanted to create an atmosphere of space and distance. Contrast this version with the demonstration painting. There is less **Brown Madder** bleeding into the sky. The foreground is more open. The painting is just as strongly stated — but it is calmer and more serene.

Critique

The painting with the three figures is more pleasing, because the figures provide more depth in the foreground. The figures have a sense of motion.

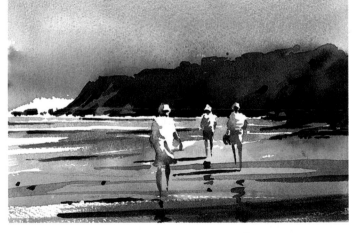

Add a figure

How the figures are placed adds interest and dimension to the scene. The eye travels into the picture with the figures. Notice too, how all the heads are on the same horizon line, but their feet are on different planes, giving an impression of distance.

Exercise

Have a go at painting the scene with three figures.

In all cases, a balanced use of white paper repeating throughout the painting adds sparkle. It also provides unity through repetition.

Project 8 simplifying a crowded scene

Cooling Off

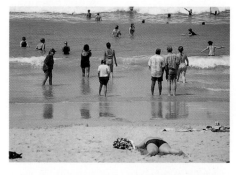

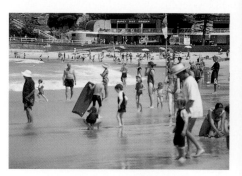

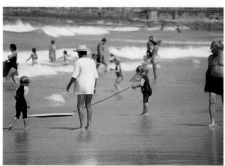

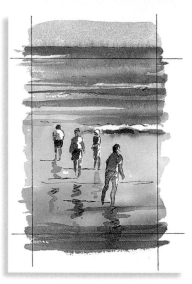

A preliminary design sketch will make everything easier. Notice the wedge-shape placement of the figures and their reflections.

1 Make your pencil drawing paying attention to the proportions of the figures and their placement in the picture frame. Initially, you will be working on dry paper so when you have finished your pencil sketch, tape the paper to your board.

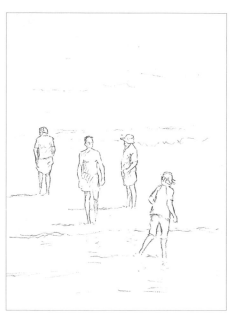

What you will need

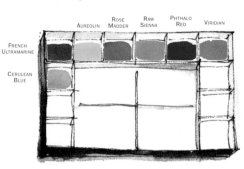

FRENCH ULTRAMARINE · CERULEAN BLUE · AUREOLIN · ROSE MADDER · RAW SIENNA · PHTHALO RED · VIRIDIAN

Paper

140lb (300 gsm) Rough,
12 x 7" (30 x 18cm)

Brushes

Wash brush #8
Round synthetic brush #12, #8 and #4

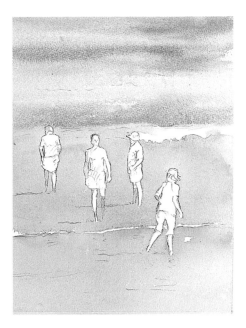

The horizon line or eye level is above the picture — we are looking down on the figures

Reserve the figures and the whites for the waves

Beaded wash

There must be soft edges where the color changes

Variegated wash

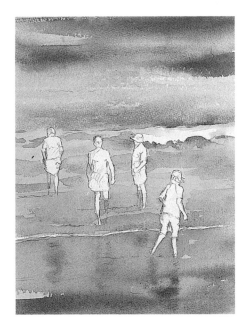

Develop the background wet-in-wet and create some hard edges

Paint short

This first wash must be applied as a very wet, beaded wash. Wash in the background water with a **Cerulean Blue/Viridian** mix, describing the movement of the water. Switch to **Raw Sienna** for the foreground, dropping in a little **Rose Madder**, and model with a touch of the water color. Make sure you retain the sunlit sides of the figures. Dry with your hairdryer.

3 Your next step is to apply a glaze to further develop the background. Using varied mixes of the colors to date, model the background waves (add a little **French Ultramarine** to the **Cerulean Blue/Viridian** mix). Describe the shallows and the breaking wave, glaze a grayed mauve over the foreground and state the figure reflections wet-in-wet. Make sure to paint short — leave plenty of the first wash showing. Dry with your hairdryer.

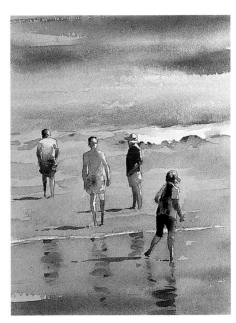

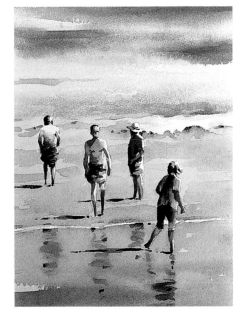

Critique
Would cropping the painting to make the figures more prominent improve the composition? What do you think?

With a mix of **Raw Sienna** and **Rose Madder** begin modeling the figures. Start at the top of each figure and work downwards, allowing the colors to blend as you go. Vary the intensity of the colors to begin suggesting form, and retain some highlights (white paper) on the figures to stand them out from the background. Reinforce the reflections and quickly state the cast shadows. Apart from the bright red, the colors are those we have already used. Dry with your hairdryer.

5 Add movement and dimension to the figures by further modeling. Apply some accents to the foreground to complete the painting. Do not overdo these accents — a little goes a long way. Notice the way the focus sharpens in the foreground, and how the figures vary in size and placement in the picture plane.

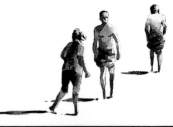

Exercise
Now try some more beach scenes. Try rearranging the figures in the project painting.

Project 9
Emphasizing the light and movement of the beach

Brighton — Melbourne, Australia

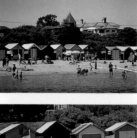

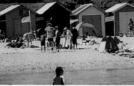

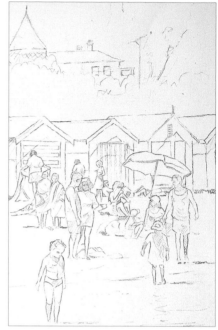

The danger of maintaining sharp edges for the figures is that they may look as if they are stuck-on cardboard cut-outs, isolated from their environment. However, knowing that this is a potential danger, you should be able to avoid it.

A strong painting requires a strong drawing, so make sure that's what you do.

The intense light will require intense primary colors and strong values. Don't be wishy-washy.

1 Make a careful initial drawing. Thoroughly soak the paper, then towel dry to provide a flat surface upon which to work. Don't tape the paper down, the wet paper will stick to your board.

Notice how I altered the angle of the water movement to provide tension, or counterbalance, to the angle of the bathing hut rooflines. Be prepared to rearrange things.

The Challenge

To simplify a busy, bright, sunlit beach scene so that the figures suggest movement and give context to the picture. The strong sunlight demands clarity of edges to make nice, crisp images

Design

There will be a visual pathway from the foreground figure, through the crowd on the beach, along the bathing boxes, across the trees to the house and up to the clouds. Overlapping elements within the scene creates big shapes

Techniques you will use

The first part of the painting will be done on damp paper, establishing the initial washes very wet, with lots of blurred edges
The second (detail) stage will be completed on dry paper
Drybrushing

Viewpoint

Very slightly looking down on the scene

Angle of Light ↘

Overhead, top left

Expression

This painting attracted me because of the intensity of the light, which will be the major element and will make the painting stand out from the pack

 Here's a breakthrough idea — when faced with a packed scene CHANGE THE FORMAT! By zooming in on just a slice of a wide, complex scene like this, you will give yourself the chance of producing something good. Here are my quick, free sketches of design possibilities and content.

What you will need

Palette

Many of the colors are primary, reflecting the bright, sunlit mood of a summer's day at the beach.

Paper

140 lb (300gsm) Rough
30 x 18" (76 x 45cm)

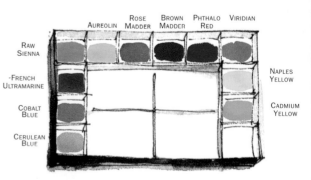

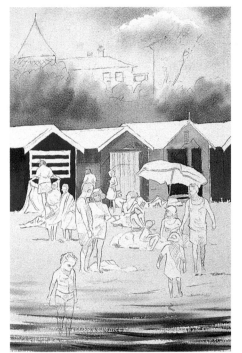

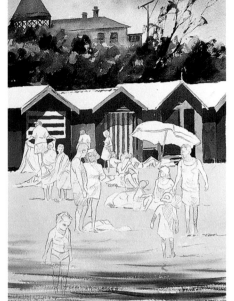

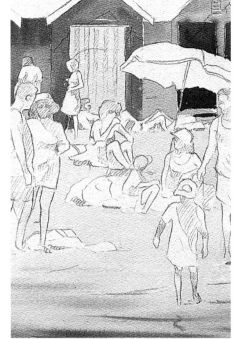

2 In this initial stage your goal is to establish the base color. Because you don't want the details to blend into the background, keep it all sharp edged, and be sure to paint the background wash AROUND the figures. Add color to the bathing huts, making the color stronger in the shadows. Introduce the reflections in the water.

3 Working from the top down, introduce the background buildings, telegraph pole and then start on the foliage. Onto your base foliage green, introduce some dark green and some warm colors to give variety. By this stage the distant background should be pretty well finished. Add stronger color to the bathing boxes, but do not finish them until you finish painting the figures. Working this way will enable you to judge how much you need to do in order to keep the painting in balance. Once all the big, wet washes are complete, staple the paper to your painting board while the paper is still damp. When it dries, the paper will become taut, providing a nice flat surface upon which to paint the figures and accents.

4 Here's how your figures should look. Notice where I have indicated the shadow areas. Work progressively, developing the form and character of each figure, looking for counterchange.

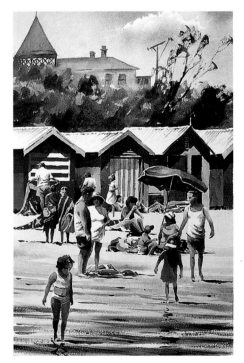

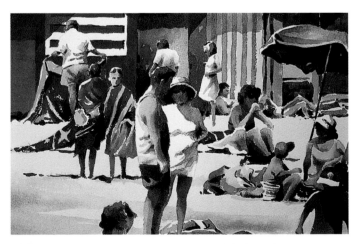

5 Remember to unite the figures and their environment to avoid the cardboard cutout effect. As you model the figures, scan the entire painting for balance and harmony.

6 When you are ready to finish the bathing boxes and the background, you can accentuate form and loosen up hard edges where you don't want them. The last thing is to give some sparkle and movement to the foreground water. Notice the drybrush effect.

What's going on here?

Brighton Horizons

 Notice how I made no attempt to detail the city buildings — they are just mid-tone shapes of gray, with some touches of darker tone for modeling.

The line of bathing sheds for which the beach is famous has also not been overdetailed, just the shapes placed in a dynamic, angle.

 I simplified the mass of boats into indistinct shapes and a forest of masts. The foliage on the headland is also one vague shape, livened up by color.

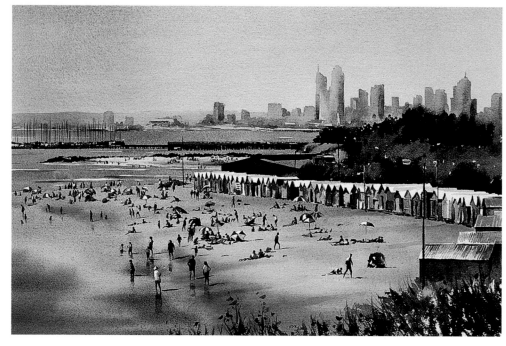

 Foreground is more detailed.

The figures on the beach and the beach umbrellas are just defined enough with dark tones to give all the atmosphere of a bright, sunny day.

A complex scene
Here's a painting I made of Brighton, with the city of Melbourne skyline in the distance. Study the edges in this painting.

Here's how you might simplify it
This sketch reduces the number of beach huts and treats the skyline, foliage and marina even more simply. Sending most of the people back to work means only a few figures to place, but the overall message is still that of a bright, sunny day.

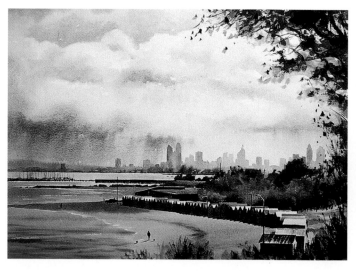

Shifting viewpoint is another way to simplify
This is winter on Brighton Beach. The colors are cooler overall, and look what's happened to the colorful row of beach huts — they are a subdued range of grays. The sky looks cold and threatening, and there's a squall over the city. Even the foreground foliage looks bleak. A couple of stalwart locals walk their dogs on the deserted beach. This is expression.

Exercise

Try painting this scene without including too much detail.

Study this scene and work out how you would simplify it. Make a few color sketches. For a better understanding of beach scenes, try painting some cameo figures. Look at the examples here to see how simply they can be done.

▼

Always walk around a scene to find other possibilities
This glimpse through the bathing sheds allows for an interesting foreground and plenty of background shapes. Fewer figures lessen the overall activity.

Here's another version
There's a lot going on in this scene, but by changing the viewpoint I eliminated most of the background, the marina, the foliage on the headland and even the foreground trees. All I had to concentrate on then was the activity on the beach.

Project 10
Suggesting movement and action

Bayside – Couta Boat Action

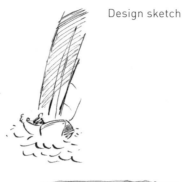
Design sketch

Pen and wash color sketch

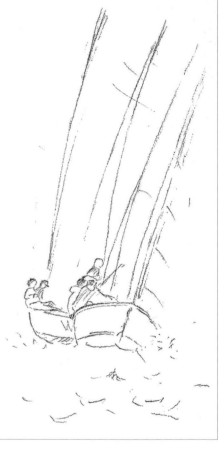

1 Draw the scene briefly with an HB pencil. You will be working on dry paper, so tape the paper firmly to a lightweight board with masking tape.

? The Challenge

To capture all the movement and excitement of a yacht race

Design

An elongated painting, with the masts at an angle

Techniques you will use

Limited palette
Gradated wash
Variegated washes
Glazing wet-in-wet
Glazing wet-on-dry
Reserving white paper
Painting short
Creating movement
Counterchange
Directional brushstrokes
Direct painting

👁 Viewpoint

Eye level

☀ Angle of Light →

Midday, light from left

★ Expression

Choppy water, lots of movement created with random brushwork and directional brushstrokes

What you will need

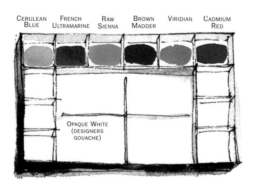

CERULEAN BLUE · FRENCH ULTRAMARINE · RAW SIENNA · BROWN MADDER · VIRIDIAN · CADMIUM RED

OPAQUE WHITE (DESIGNERS GOUACHE)

Paper
140lb (300gsm) Rough
15 x 11" (38 x 28cm)

Brushes
Wash brush #8,
Round synthetic, #12 and #6

Create soft ragged edges.

The directional brushstrokes of the gradated wash should echo the movement of the yachts.

Model the figures directly with strong pigment.

Observe the light coming through the sails.

Manipulate the board to encourage the sail colors to merge.

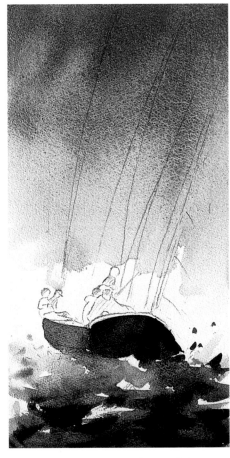

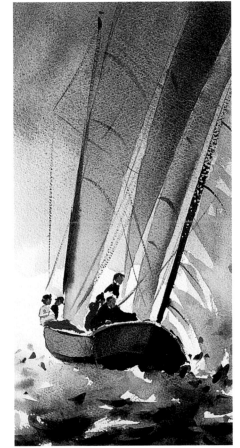

Directional brushstrokes should describe the choppy water.

Raw Sienna links the foreground to the sky.

Random brushstrokes help create a sense of movement.

Quick drybrush strokes enhance the feeling of motion and excitement.

Maintain the light on the water.

It is important to keep this stage very brief, loose and lively and don't overdo the accents.

2 With the board at a slight incline (5-10°) to the horizontal, wet the sky area, then apply a gradated wash of **Cerulean Blue**, **French Ultramarine** and **Raw Sienna**. Stop the wash at a ragged edge above the figures on the boats. Use a varied wash of **Cadmium Red** and **French Ultramarine** for the boats, then go straight into the water with **Raw Sienna** and **Cerulean Blue**, modeling wave movement with mixes of **French Ultramarine**, **Cadmium Red** and **Viridian**. Soften some edges, but make sure you maintain the light on the water immediately below the boat. Dry with your hairdryer.

3 Paint the sails with very wet **Raw Sienna**, and float in some color from the water mixture. Try to capture the feeling of light coming through the sails. While the sails are still wet, paint the masts and rigging with quick, single brushstrokes, using a strong mix of **French Ultramarine** and **Brown Madder**. State the figures directly with strong, juicy, pigment, modeling form wet-in-wet. Define the form of the boat with a strong **French Ultramarine** and **Brown Madder** mix and reinforce the movement of the water. Again, do not lose the light in the water immediately below the boats! Dry with your hairdryer.

4 Now for the final accents which sharpen the form and punch light into the scene. Use **French Ultramarine** and **Brown Madder** for the dark accents. For the light accents use **Opaque White** and **Cerulean Blue**.

Exercise
Now try this project again, this time using different colors!

105

Project 11
Coming to grips with mood and atmosphere

Sorrento Mooring

What's going on here?

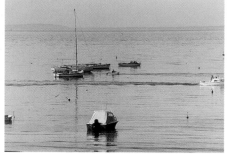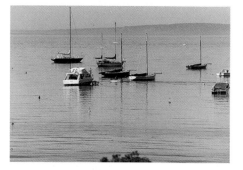

These photos of the scene show the utter quiet and tranquility that captured my attention and inspired me to paint.

 The Challenge

To capture the tranquil mood of sunlight dancing on the boats, flooding them with light

Design

Balancing the vertical and horizontal elements and connecting some masts to the sky and to the foreground using reflections

Techniques you will use

Reserving white paper
Varied washes
Reflected warmth
Wet-in-wet
Tonal definition

 Viewpoint

High horizon — looking down

Angle of Light →

From the left

Expression

Mood and atmosphere

Details reveal contrasting techniques

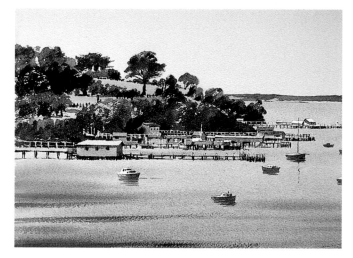

Command of tone suggests a bright sunny day.

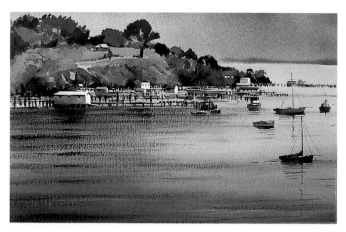

Drybrush work, restrained tone, subdued color and effective brushwork give this a brooding quality.

The sky should be done with a flat wash. Notice how the color in the sky is repeated in the water.

Time of day is suggested by the sky color — very early morning?

To emphasize the utter stillness, all the masts are carefully vertical.

Connect the masts to the sky and connect their reflections to the foreground.

Paint reflections in the water to enhance the feeling of stillness.

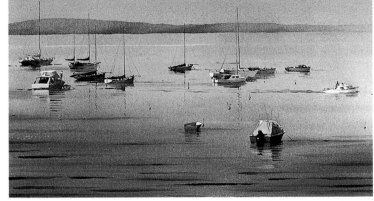

Keep the distance soft and indistinct.

Make a few dark brushstrokes in the water to accentuate the light and complete the painting.

Use horizontal lines to break up the foreground and suggest a long, slow, peaceful swell.

I made some quick jottings with a pen, splashed on some color, and I was on my way to a pleasing composition.

Paint the boats simply, and connect them to the water with their reflections. Keep detail on the boats to a minimum.

Notice where the darkest darks are and where the lightest lights and reserved white paper are.

Creating two different moods

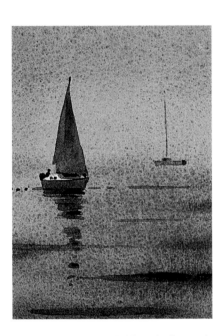

Analyze the mood of this painting and write down the techniques used to achieve the various effects.

Here's another version of the same scene. All I did was rearrange the boats.

Here's the same scene but with an overcast sky. You have permission to be a dramatist — if you want a stormy sky you can make one. That's what I did with this scene.

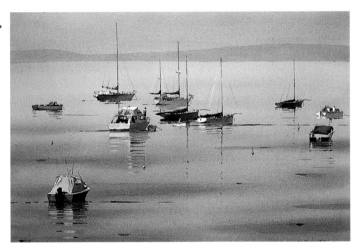

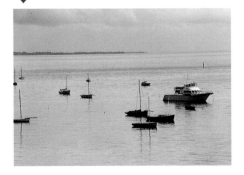

Study this tranquil scene full of atmosphere.

My pen and wash sketch shows how I intended to play up the idea of a storm brewing.

Exercises
Paint both scenes — the tranquil scene and the storm brewing one.
Pay close attention to the way you suggest the mood in each painting.

Project 12
Simplifying buildings and streetscapes

The Windsor

 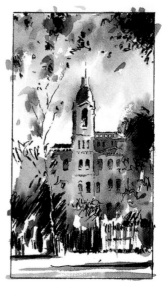

? The Challenge

To paint a detailed architectural subject in a simple but expressive way

Design

There will need to be a strong horizontal element to balance the vertical nature of the scene, as well as to anchor the building

Techniques you will use

Variegated washes
Dropping in local color
Limited palette
Preserving white paper
Painting short
Counterchange
Directional brushstrokes

Viewpoint

Eye level

Angle of Light ↓

The sun high in the sky

★ Expression

To portray the light falling on the charming Victorian facade of this stately old hotel which is softened by a framework of vegetation, and conjures up images of a past, golden era

! Beware

It must not look like a stiff, architect's rendering with hard lines, hard edges and too much attention to detail

I played around with designs that simplified the scene.

Here's the design I liked best. As you can see, I cropped the scene heavily to focus on the building, and to mirror the verticality of the subject.
I replaced the traffic sign (at the expense of losing a delightful red accent) with the slender tree, thus establishing a frame through which to view the subject.

The verticals repeat throughout the painting — the picture format, itself, the trees, and the building. Subtle horizontals repeat through the building. The tower is set marginally off-center.

What you will need

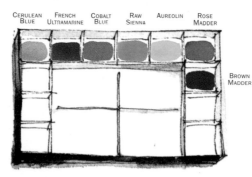

CERULEAN BLUE FRENCH ULTRAMARINE COBALT BLUE RAW SIENNA AUREOLIN ROSE MADDER

BROWN MADDER

Paper

140 lb (300gsm) Rough
15 x 9" (38 x 23cm)

Brushes

Wash brush #8,
Round synthetic, #1, and #8
Long handled sable rigger, #4

Preserved white paper describes architectural detail as well as helping to control the wash.

Local colors dropped in very wet, so that the colors merge seamlessly without hard edges.

Edges controlled by white paper.

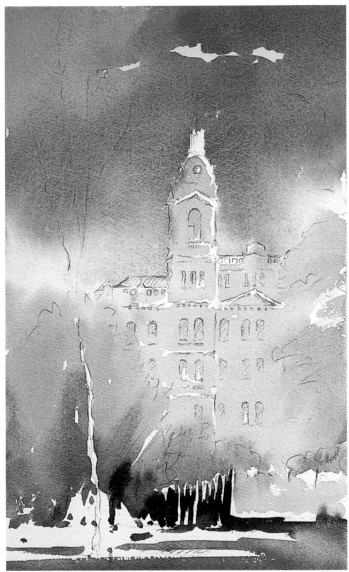

Cool green Warm, bright green Deeper green Darker

1 Sketch the scene briefly onto watercolor paper. You will be working on dry paper so tape the paper securely to your painting board.

2 This first stage is a variegated wash with local colors dropped in very wet, so that the colours merge seamlessly.

Onto dry paper, wash in the sky using **Cerulean Blue**, **Cobalt Blue** and **Rose Madder**, allowing them to mix on the paper. For the building use light, transparent **Raw Sienna**, reserve white paper to suggest architectural detail and to indicate the direction of light.

Allow the sky to blend with the building on the shaded side, and add a touch of mauve color (**Cobalt Blue** and **Rose Madder**) to the building to further vary the wash.

Suggest tree shapes using varied mixes of **Cerulean Blue**, **Cobalt Blue** and **Aureolin**, with the darker tones at the base being **French Ultramarine** and **Brown Madder**. Keep the direction of light in mind when you paint the tree colors. Suggest the foreground with a couple of quick brushstrokes of mauve. Dry with your hairdryer.

109

Patterns of white throughout the scene enhance the light and provide sparkle.

Small accents sharpen the focus.

Three or four accents look great, 30 or 40 will look lousy. KNOW WHEN TO STOP.

Use directional brushstrokes to describe form and shape.

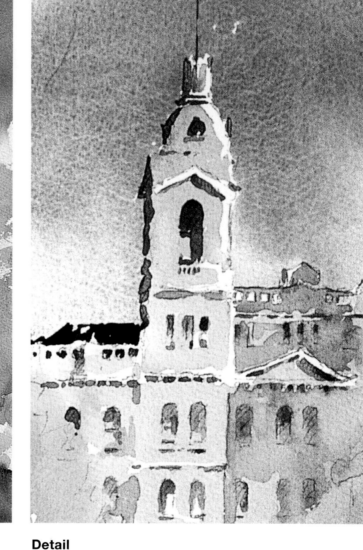

Paint short.

Soft mauve brings the tower forward.

Allow the sky color to drift into the building, enhancing the fluid, artistic nature of the approach.

Detail
Allow the colors to drift.

3 Remember to suggest rather than record detail. Using a soft mauve consisting of **Cobalt Blue** and **Rose Madder**, model the building by painting the shade areas. Vary the mix by dropping in Raw Sienna here and there. Keep it loose and abstract. It is important to suggest rather than record detail. Dry.

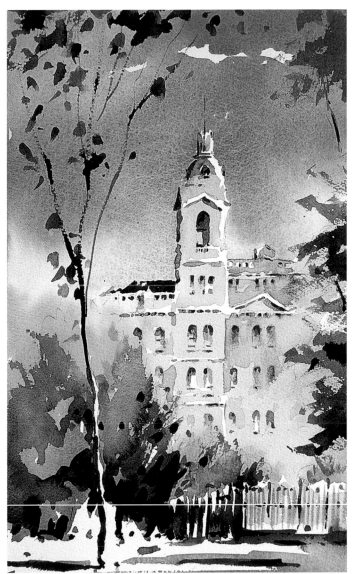

What a difference a glaze makes

Here's another version of the same scene, but this time I have taken it a step further by applying a loose, wet, broken glaze of mauve (**Cobalt Blue** and **Rose Madder**) over the building. Remember that glazes must be applied when the underlying pigment is completely dry.

Don't be afraid to experiment — to explore the possibilities of both the subject and the medium, and to sharpen your creative instincts. **If you mess it up, write it off to experience, and gain from it.**

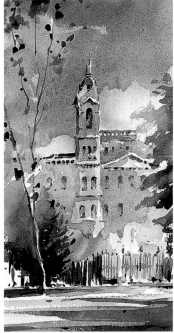

The strong tonal contrasts in the foreground provide horizontal balance to the verticals.

The foreground, being loose and abstract, is an effective foil to the more formal rendering of the Windsor Hotel.

A different mood

Let's try backing off a little. This time give the sky a little drama and add a wet pavement after a summer shower

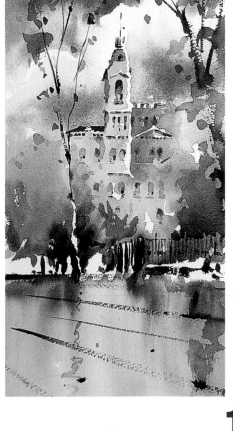

4 Using varied mixes of **French Ultramarine** and **Aureolin**, and **French Ultramarine** and **Brown Madder**, model the trees and fence. Apply directional brushstrokes to describe the form and shape of the trees — and PAINT SHORT! Apply strong accents to the building to bring it into focus. Dots and dashes — but not too much.
IF IT LOOKS OKAY, PUT YOUR BRUSH DOWN!

Exercise
Try glazes of various mauve color all over the painting. A good glaze of Rose Madder and Cobalt Blue will achieve an evening effect.

Project 13

Striking a balance between too much and too little activity

Paris End, Collins Street, Melbourne

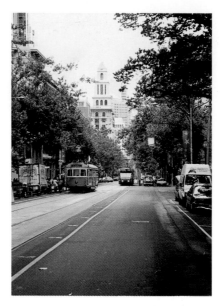

You must get the perspective right at the beginning or all the elements in the painting will look odd.

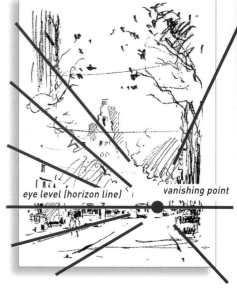

eye level (horizon line) *vanishing point*

When you make a perspective drawing make sure you show the eye level (horizon line) and the vanishing point. Once you have these reference points you will know where all the other objects should be.

?

The Challenge

To simplify a busy street scene, but still include enough movement to make it believable and interesting

?

The Challenge

To simplify a busy street scene, but still include enough movement to make it believable and interesting

Design

Always know what the focal points of your painting will be before you begin!
Here they are the building and the tram

Techniques you will use

Establish the initial washes very wet, with lots of blurred edges, and then develop the form and detail as the drying of the paper allows

Viewpoint

Eye level

Angle of Light

From the right

Expression

A bright, sunlit city streetscape, with lots of atmosphere painted in a somewhat impressionist way

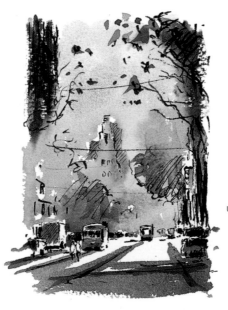

The preliminary pen and wash sketch helps to establish the shapes, the lead-ins and the color. Here, the main building is emphasized using complementary color.

What you will need

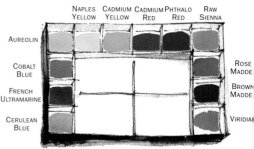

	NAPLES YELLOW	CADMIUM YELLOW	CADMIUM RED	PHTHALO RED	RAW SIENNA	
AUREOLIN						
COBALT BLUE						ROSE MADDER
FRENCH ULTRAMARINE						BROWN MADDER
CERULEAN BLUE						VIRIDIAN

Palette

Even though it looks like a lot of colors this is a relatively limited palette. 95 per cent of the painting will be done with seven colors, the remainder will be accent colors.

Paper

140lb (300gsm), Rough
30 x 22" (76 x 56cm)

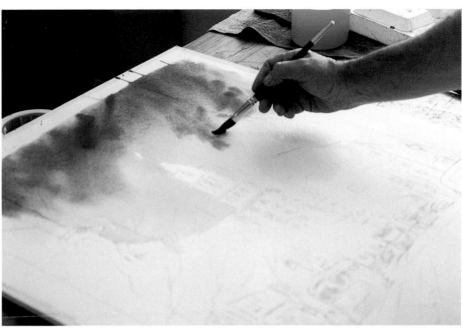

1 The drawing is relatively detailed at eye level, which is where all the action takes place, but even here, only the broad shapes of the buildings and the cars are stated because their detail will be developed with the brush as the painting proceeds. Everywhere else, the drawing is only sufficient to guide you through the painting. Add a few figures for interest and believability — a city streetscape without human activity looks sterile, and the fact you haven't included figures may lead the viewer to think that you are not comfortable painting them.

2 Lay a big, wet, variegated wash of Cerulean Blue, French Ultramarine, Raw Sienna and Rose Madder in the sky and work down, dropping in local colors to establish the general mood. Use the dry paper to control edges as required.

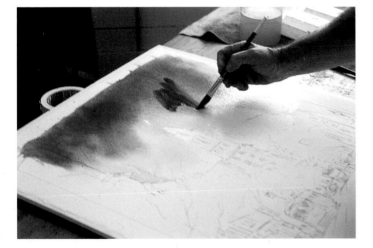

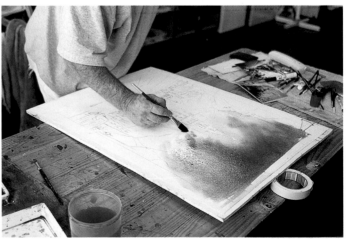

3 Develop the mood, atmosphere and values, working quickly and broadly into the wet paper.

4 Just a slight angle is fine. Mop any excess moisture from the paper with your kitchen sponge.

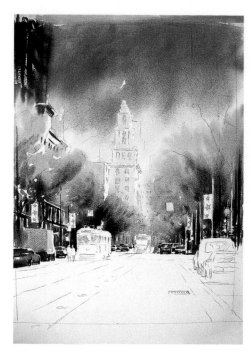

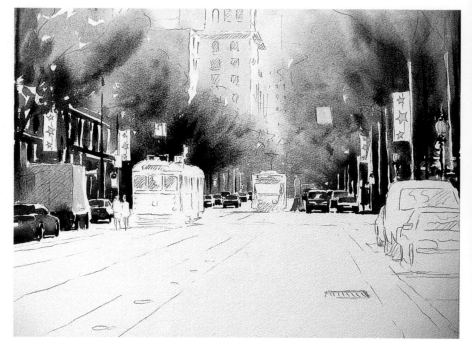

5 Now we zoom in on the action. The following steps should all be painted wet-into-wet, keeping a strong emphasis on tonal values. Use this picture as your guide for the following steps.

6 While the paper is damp, establish the first hint of the building and the trees, working progressively forward.

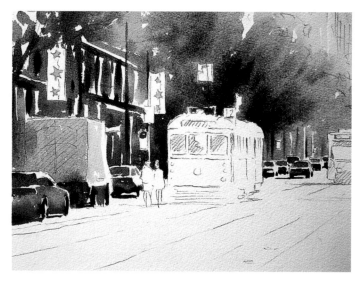

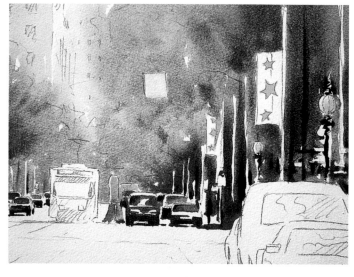

7 Further model the trees and begin more intense modeling of detail along the eye-line. Use dry edges to describe form. Progressively paint with stiffer mixes of pigment to create dimension. **Use softer, cooler colors in the distance, with stronger, brighter colors in the foreground.**

8 Look closely at the shapes, and you will see that while the broad shapes are accurate, the detail is **SUGGESTED**, with lots of merging of colors. Use bright, primary colors in the foreground to heighten the sunny feeling.

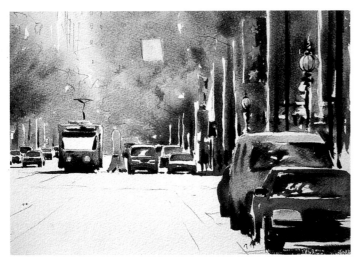

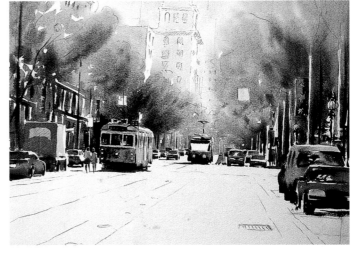

9 Okay. Once the top half of the first wash is finished, you can carry on down the sheet. While there is moisture in the paper, (it is still lying flat on the painting board), paint the shapes of the traffic.

10 To maintain the bright sunny feeling, don't let the busy activity of the street (people, cars, trams) bleed into the road. Instead, wait for this detail to dry — you need crisp definition here.

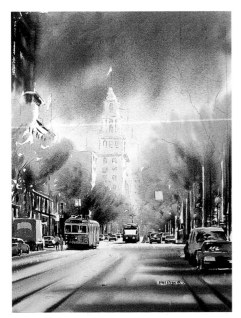

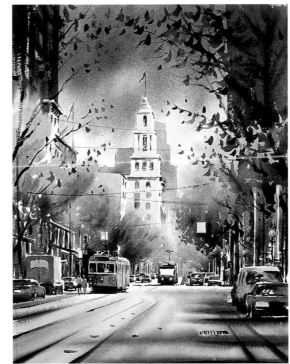

At all times keep in mind the light and movement in the street.

Towards the end you should be painting with pure tone.

The intense activity at eye level is also counterchanged by the relatively calm simplicity of the roadway.

Use a long-handled rigger for the trees.

The eye level activity is also balanced by the movement of the leaves.

11 Next, wet the road with clear water and lay in a wash using the colors already used throughout the painting to ensure unity. Keep the light focused on the distant road surface and model the foreground with directional brushstrokes.

12 Move around the painting, adding accents here, blending edges there, all the time keeping an eye on the progress and balance of the painting **as a whole**. It is important to achieve that balance of movement throughout the painting so that it remains interesting and appealing.

If you go too far, the painting could become busy and visually overactive. If you haven't gone far enough it could be pallid and boring!

Trial and error (experience) eventually tells us when we have got the balance right.

Project 14 Changing your point of view

Princes Bridge, Melbourne

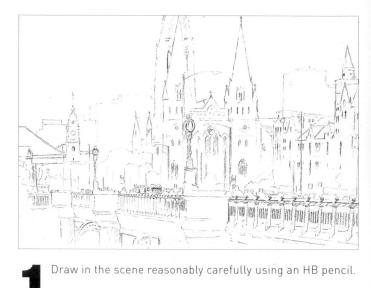

1 Draw in the scene reasonably carefully using an HB pencil.

The Challenge

To simplify the scene with a carefully chosen viewpoint, to reduce the background to shapes and maintain uniformity to the painting

Design

To simplify the scene with a carefully chosen viewpoint, to reduce the background to shapes and maintain uniformity to the painting

Setting the bridge at an angle introduces a dynamic element. Cropping the church spire suggests an intimate snapshot of this busy scene. An eye level viewpoint minimizes all the traffic and clutter of the bridge

Techniques you will use

Floated washes
Gradated washes
Wet-in-wet
Wet-on-dry
Glazes

Viewpoint

Eye level

Angle of Light

We are looking into the light

Expression

This classic view of Melbourne city evokes a powerful image of a byegone era

What you will need

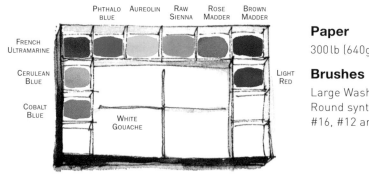

	PHTHALO BLUE	AUREOLIN	RAW SIENNA	ROSE MADDER	BROWN MADDER
FRENCH ULTRAMARINE					
CERULEAN BLUE					LIGHT RED
COBALT BLUE		WHITE GOUACHE			

Paper

300 lb (640gsm) Rough

Brushes

Large Wash brush #12, Round synthetic, #16, #12 and #8

Variations on the same theme

Scenes such as this provide the artist with a constant, ever-changing feast of subject matter. Consider painting the same scene at different times of the day, from a different viewpoint, giving different emphasis.

Hint: For the second picture apply a very warm wash of Raw Sienna, Aureolin and Alizarin Crimson Permanent over the entire sheet, to provide the intense afternoon glow. Keep all subsequent glazes very warm and strong, with a minimum of detail.

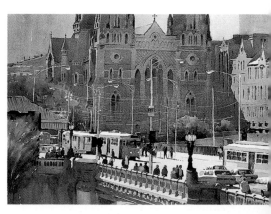

A slightly different viewpoint shows more of the bustle on the bridge, and less of the cathedral.

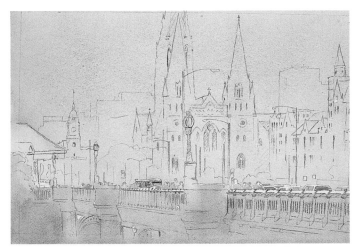

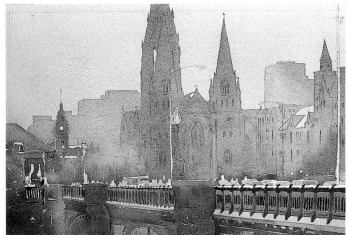

2 One at a time, float in glazes of **Aureolin**, **Raw Sienna** and **Rose Madder**. Dry with your hairdryer? Then apply a gradated wash of **Cobalt Blue** and **Cerulean Blue** to the sky. Add a warm mix of **Cobalt Blue** and **Rose Madder** to the foreground bridge, reserving white paper for the sunlit highlights. Allow the paper to dry thoroughly.

3 Begin to define the buildings using a varied mix of **French Ultramarine**, **Brown Madder** and **Light Red**. Gradually build up the tones, working all over the painting, allowing the colors to merge here and there, controlling the wash elsewhere by the use of the dry paper.

Suggest trees, trams and so on with touches of **Aureolin** and **Cobalt Blue**.

Then model the bridge with deeper tones of the colors you used for the first layer. Continue to work quickly over the whole painting because you need to do this stage wet-in-wet. As the paper dries you can do more definite modeling.

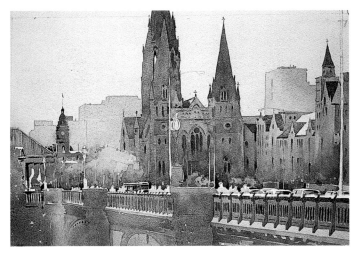

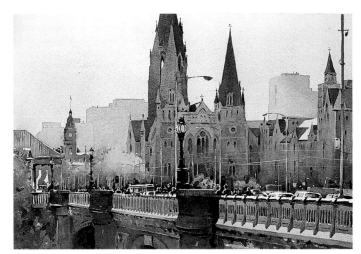

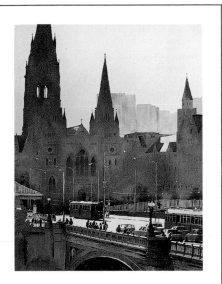

4 Now it is time to consolidate the shapes using warm and cool mixes of the same colors used previously. Gradually build up tonal values, looking for balance across the whole painting. Soften some shapes and strengthen others. Continue to work the image as a whole and resist the temptation to concentrate on any one area. Allow the paper to dry.

5 Bring the bridge to the same degree of finish as the rest of the painting. Next, concentrate on developing contrast in the area of activity on the bridge at eye level. Use **Phthalo Blue** and **Indian Red** to make a strong dark for the final accents.

Finally, using a smallish brush with a nice point, quickly sweep in the tram and power lines using opaque white. This requires a bit of nerve, because it has to be done quickly and convincingly. It also calls for a lot of restraint because you don't want to create distraction by overdoing it.

Project 15
Simplifying with complementary color

The Grand Canal, Venice

1 Draw the scene briefly, then tape your paper securely to your painting board.

2 Lay a flat wash of **Raw Sienna** and **Alizarin Crimson** evenly all over the paper. While the paper still has a surface shine, brush in a mix of **French Ultramarine** and **Alizarin Crimson** through the center. Make sure that the intensity of the two washes is in balance (that is, one does not dominate the other). Dry with your hairdryer.

? **The Challenge**
To give a soft mood to a complex scene

**Design**
A simple horizontal band through the center of the picture frame

Techniques you will use
Limited palette of complementary color
Flat wash
Wet-in-wet

Viewpoint
Eye-level

Angle of Light ↑
We are looking into the light

★ **Expression**
A quietly vibrant painting

! **Beware**
Work wet.

What you will need

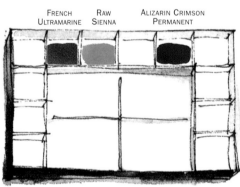

FRENCH ULTRAMARINE RAW SIENNA ALIZARIN CRIMSON PERMANENT

Paper
140lb (300gsm), Rough

Brushes
Wash brush #8
Round synthetic, #12 and #8

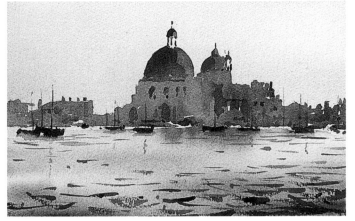

3 Paint the distant buildings with a slightly stronger mix of the previous colors. Wet the bottom half of the paper and glaze with the yellow-orange. Allow some of the buildings to bleed down. Do all of this quite wet. Add blue/mauve to the extreme foreground while the wash is still wet. Allow to dry.

4 Now begin to model the shapes and form of the buildings and foreground. Keep the detail lose and abstract — stronger in the foreground. Allow the colors to blend on the paper. Dry with your hairdryer.

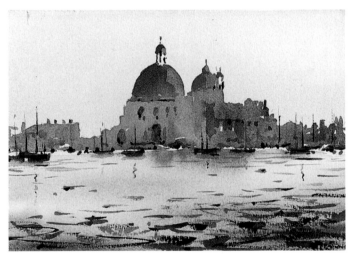

5 Add accents to create focus and to enhance the light. Take care not to overdo this stage.

Exercise
Start thinking in planes so there is a definite foreground, middleground and background. For instance, here I added some mooring poles, two gondola shapes and a bit of color to the foreground. Do you think this is a more interesting picture than the project one? Which do you prefer? Why?

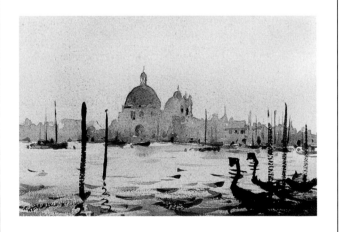

This painting is about tertiary color on the color wheel. Notice also that the two colors are on opposite sides of the color wheel, that is complementary colors!

Project 16
Balancing vertical and horizontal shapes

Venice Light

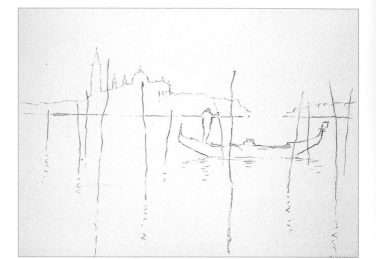

1 Draw the scene, tape the paper firmly to your board.

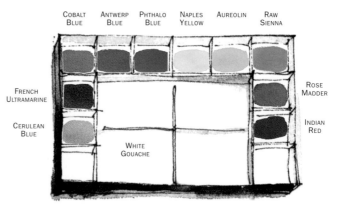

The Challenge

To portray the beauty and atmosphere of Venice simply and eloquently

Design

A very strong tonal plan enhances the effect of distance

Techniques you will use

Tone
Glazing for atmosphere
Limited palette
Wet-on-dry
Wet-in-wet

Viewpoint

Eye-level

Angle of Light

Into the light

Expression

The beautiful light, the muted distant tones of San Giorgio Maggiore and the shape of the gondola and lines of the poles

What you will need

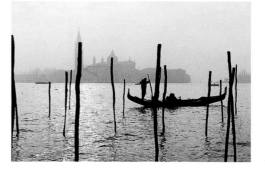

COBALT BLUE ANTWERP BLUE PHTHALO BLUE NAPLES YELLOW AUREOLIN RAW SIENNA

FRENCH ULTRAMARINE

CERULEAN BLUE

WHITE GOUACHE

ROSE MADDER

INDIAN RED

Paper

140 lb (300gsm) Rough
11 x 15" (28 x 38cm)

Brushes

Wash brush #12,
Round synthetic, #10 and #12

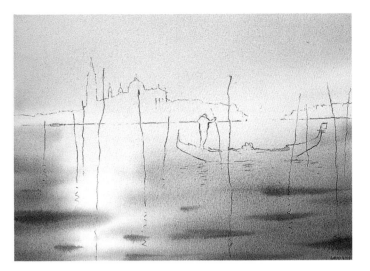

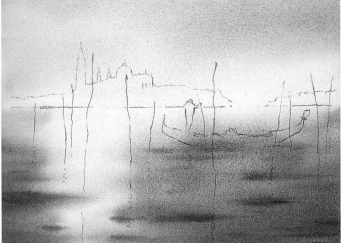

2 Wet the paper all over and wash a mix of **Cobalt Blue** and **Rose Madder** into the sky. Draw the wash down into the water, leaving the light reflection as white paper. Model the water with a mix of **French Ultramarine** and **Rose Madder**. Dry thoroughly with your hairdryer.

3 Wet the paper all over, float in a mix of **Naples Yellow** and **Aureolin** into the reflection, with just a touch for the sky. Float in a mix of **Cerulean Blue** and **Rose Madder** to the top of the sky and further model the water with varied mixes of mauve. Do all this while the paper is still wet.
Dry with your hairdryer.

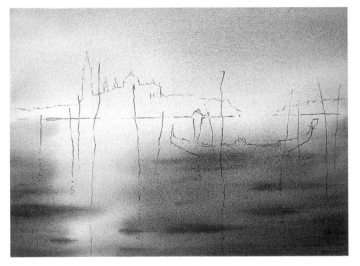

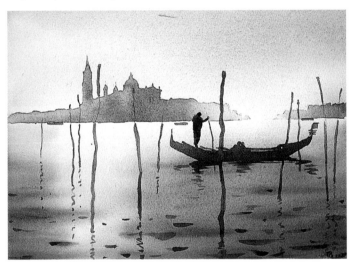

4 Wet the paper all over. Glaze an **Antwerp Blue** and **Rose Madder** mix on top of the water, avoiding the reflection! Apply a glaze of **Rose Madder** to the sky.
Dry with your hairdryer.

5 Using varying mixes of warm and cool grays (made from **Cobalt Blue**, **Rose Madder** and **Raw Sienna**), paint the distant shore and lighten off near the channel. Use stronger mixes of the above grays (add **French Ultramarine**) to describe the foreground detail. Dry with your hairdryer.

Strong tonal recession.

A strong balance of vertical and horizontal shapes.

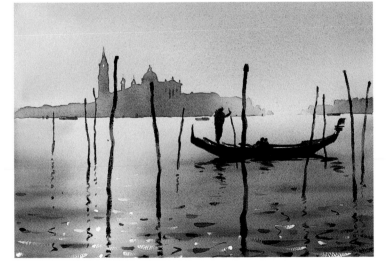

There is an escape route for the eye through the distant channel.

The poles connect the foreground to the sky.

6 Apply final accents with a very strong **Phthalo Blue** and **Indian Red** mix, and a **white gouache** and **Aureolin** mix. Keep these accents brief.

Project 17 Expressing activity

Market Day

1 Study the photograph then read the design parameters and see if this drawing meets the requirements.

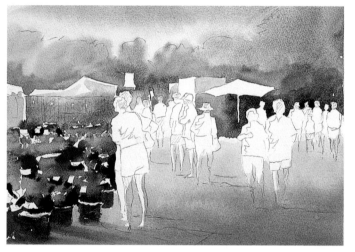

Make soft edges to the background trees.

Establish these shapes carefully while doing the background wash — these are the shapes you will be stuck with.

Paint the flowers strongly and directly.

Make a warm foreground.

2 With the board at a slight angle (5-10°) wash in the sky using **Cerulean Blue**. Strengthen the top with **Cobalt Blue**. While this is still wet, state the background trees using various mixes of **Cobalt Blue** and **Aureolin**, **Raw Sienna** and **Cobalt Blue** and **French Ultramarine** and **Brown Madder** for the darks. Suggest the background tents and sheds using soft, varied mauves made from **Cobalt Blue** and **Rose Madder**.

For the ground use **Raw Sienna**, warmed at the bottom with a strong mix of **Raw Sienna** and **Rose Madder**. State the flowers and pots strongly wet-in-wet on dry paper using varied mixes of **Cobalt Blue** and **Aureolin**, **Phthalo Red**, **Cadmium Yellow**, **French Ultramarine**, **Brown Madder** and **Rose Madder**. Dry with your hairdryer.

? The Challenge

Capture the feeling of a bright, sunny day with all the activity and movement, of a street market

Design

Vary placement of figures to ensure depth
Strong tonal contrast
A visual pathway lead-in that allows the eye to travel around the painting
The figures should suggest movement and individuality

Techniques you will use

Wet-on-dry paper
Preserving white paper
Warm, sunny colors
Variegated washes
Painting short
Tonal contrast (light against dark)
Color temperature
Verticals
Soft edges and hard edges

Viewpoint

Eye level

Angle of Light ↘

High, from the left

★ Expression

An impression of a strong, bold, bright, colorful scene full of activity

What you will need

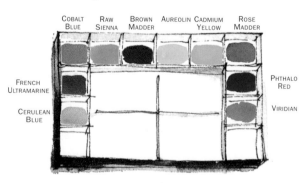

FRENCH ULTRAMARINE COBALT BLUE RAW SIENNA BROWN MADDER AUREOLIN CADMIUM YELLOW ROSE MADDER PHTHALO RED

CERULEAN BLUE VIRIDIAN

Paper
140 lb (300gsm) Rough
11 x 15" (28 x 38cm)

Brushes
Wash brush #8, Round synthetic, #12, #8 and #6

Counterchange — figures placed against a light foreground.

Paint the figures with strong colors encouraged to blend.

Retain light on sunlit side of figures.

The eye should be able to move comfortably around the painting and find areas of interest.

Small accents placed mainly in the foreground and on a few of the figures.

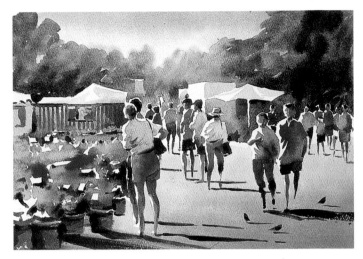

Strong shadows punch intense light into the foreground.

Drybrush strokes

Counterchange — the dark tonal values of the background contrast with the light on the figures.

No faces, no feet, no fingers or toes — SUGGEST! Make broad but believable strokes. It is the body language that is important.

A mix of soft and hard edges (lost and found) are kept within a simple framework that avoids visual confusion.

3 Strengthen the background trees with varied mixes of the original colors but add **Viridian**. Paint the figures strongly, beginning with their heads and working down, allowing the colors to merge. For the skin tones use **Raw Sienna** and **Rose Madder**, with the distant figures softening in strength of color (hue). Be careful that you preserve the light falling on the figures because this helps describe their form and gives them movement. This light will also make them stand out from the background. State the strong cast shadows with quick, single brushstrokes of **French Ultramarine** and **Brown Madder**. Dry with your hairdryer.

4 Place strong darks (**French Ultramarine** and **Brown Madder**) strategically to emphasize the light and describe form. The strong accents punch light into the scene. Try not to explain everything. When you have finished stand back and study your effort. Add a few birds in the foreground using tadpole brushstrokes.

Exercise
Here's another market scene and my simplified version of it. See what you can do with the same scene.

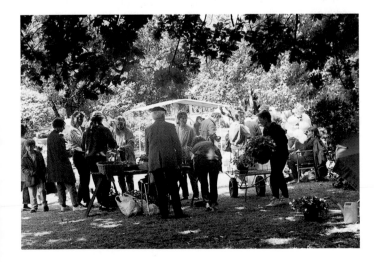

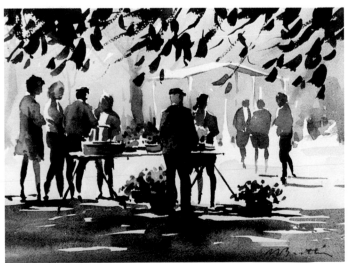

Project 18 Working with complex abstract shapes

Farm Junk

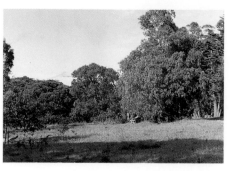

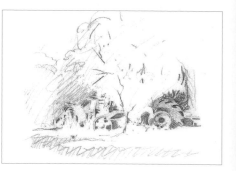

Like most people, when I am driving in the country I occasionally come across old farm machinery lying forgotten and decaying in the corner of a field. The rust, peeling paint and interesting shapes and forms provide irresistible subject matter for the watercolor junkie. The main mood in this painting is the suggestion of light shining through the trees and playing upon the foreground.

Negative space is the space around the object that helps defines it — is just as important as positive space.

1 Sketch the scene loosely and briefly with an HB pencil, taking care to plan the shadow areas that describe the derelict tractor.

What you will need

CERULEAN BLUE FRENCH ULTRAMARINE NAPLES YELLOW AUREOLIN LIGHT RED

Paper

140 lb (300gsm) Rough
11 x 15" (28 x 38cm)

Brushes

Wash brush #8,
Round synthetic #10 and #12

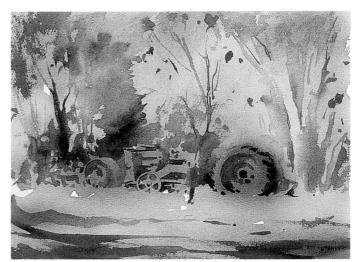

2 Thoroughly wet the paper on both sides. Let it settle for five minutes or so, then towel dry the surface. This toweling serves to press the paper flat into the painting board, which is placed on an angle of about 5-10° for painting. Then float in a very wet wash of the local colors, allowing all the edges to merge seamlessly. This stage establishes the perceived background light and sets the mood. Allow the painting surface to dry.

3 Begin to develop the broad shapes using mid tones. Be patient. Try not to paint too much detail.

The foreground shadow and the trees frame the subject matter. Notice how the foreground shadow suggests the presence of an object, probably a tree, beyond the limits of the painting.

Lost and found edges abound.

See if you can identify where I painted "negatively".

Notice the few spots of reserved white paper.

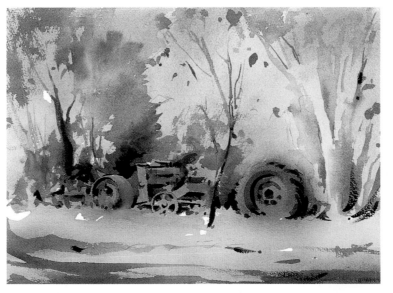

Likewise, the background trees are pushed beyond the edges of the painting, inviting the viewer to place the scene within its broader environment.

There is unity of color throughout the painting while the complementary warm and cool colors keep the scene fresh and vibrant.

Treat the surrounding areas very abstractly and simply.

This painting is much more interesting than the photograph.

4 Once the previous shape is dry, sharpen up the focus and resolve the light by placing the dark accents. The last two stages are mainly defining form with tonal values — the grays and greens.

Exercise
Have another go at this scene, but this time you choose the color scheme and direction of light.

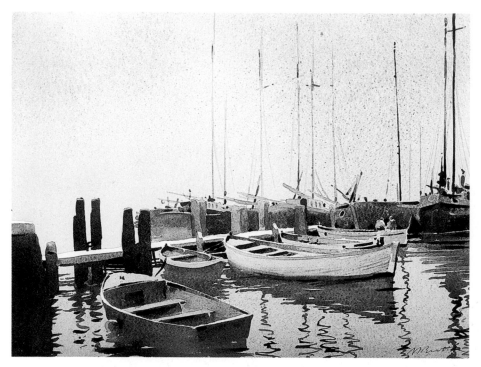

At anchor
watercolor, 13 x 21" (34 x 54cm)

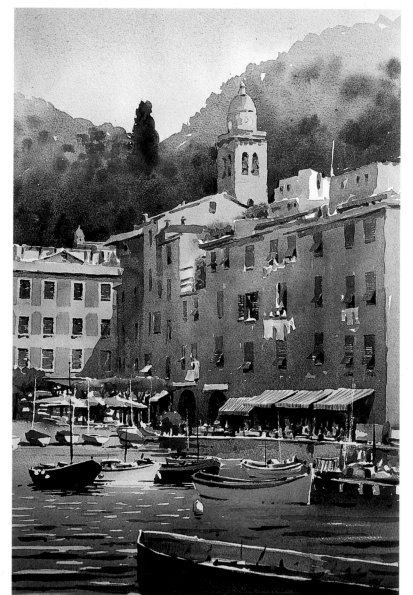

Portofino, Italy
watercolor, 21 x 14" (54 x 35cm)

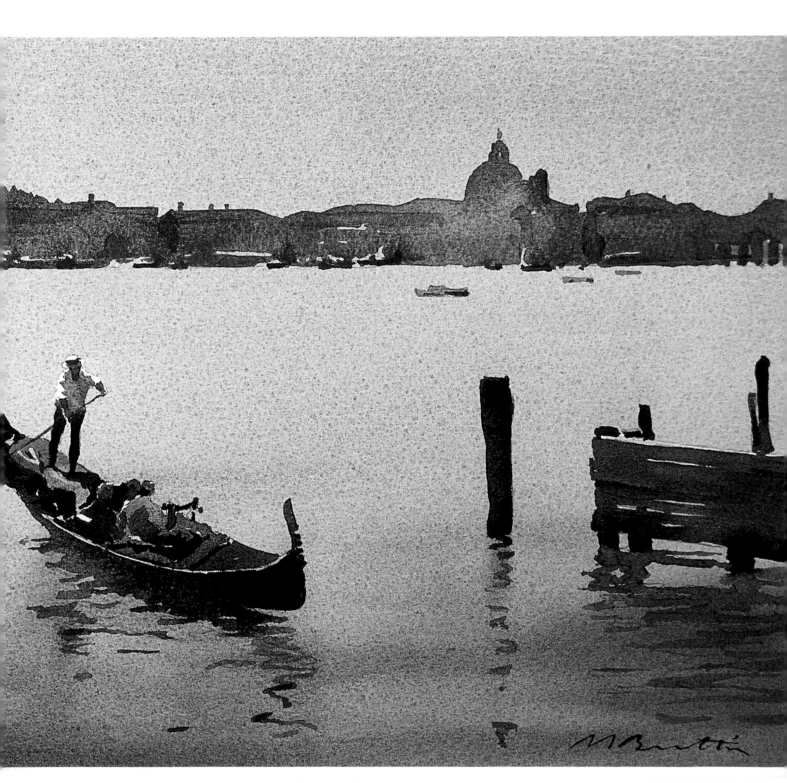

Riva Degli, Schiavoni, Venice
watercolor, 10 x 14" (26 x 36cm)

About the Artist

Malcolm Beattie was born in Australia in 1945. He is married with two children, and he works and teaches from his studio in Melbourne. As a professional artist, he places great emphasis on the composition and content of a subject. He combines sound draftsmanship and an understanding of tonal contrasts and color to produce paintings that are both visually interesting and straightforward statements of the everyday places and things around us.

His paintings depict the life and activity of his environment. Malcolm's watercolors are characterized by purity of color and a straightforward arrangement of tonal values. This emphasizes the light in his paintings and, together with a broad approach to detail and careful composition, makes them stand out from the crowd.

Malcolm's work is represented in corporate and private collections around the world and is available through a number of Melbourne and regional galleries. He undertakes regular workshops and demonstrations throughout Australia, and runs a school conducting classes in both watercolor and oil painting technique. He has led painting tours overseas, and is a regular contributor to *Australian Artist* and *International Artist* magazines.

Malcolm has won many prizes and commendations, including the prestigious First Prize and Gold Medal for Watercolor at the 1996 Camberwell Rotary Art Show, and Best Urban Landscape at the 1999 Camberwell Rotary Art Show.

Malcolm was born with a gift. From earliest memory, he could draw. He takes no credit for it, because he says it comes naturally and without effort.

From early childhood through to early teens he took great pleasure in drawing anything and everything. While in pre school, he perfected drawings of Donald Duck, Mickey Mouse, Ginger Meggs, the Katzenjammer Kids, Superman and then invented his own characters. He filled his schoolbooks with drawings, drew on the margins of his dad's newspaper his brown paper lunchbags and any other scrap of paper he could lay his hands on. He drew and painted his pet dog, his budgies, his mates, family, people in the street — anything was fair subject matter. He savored the smell of Indian ink, chewed his pencils and wore out countless crowquill nibs.

However, this all came to an abrupt end in his early teenage years due to a lack of encouragement at junior high school coupled with an increasing interest in extra curricular activities — girls, cars and hanging out with his definitely "non arty" mates. It wasn't until his middle years, after marrying, establishing a home and family that the old urge to draw and paint bubbled irresistibly to the surface. In 1988 he began painting in his spare time (anytime — before work, lunch time, after work and weekends) and was lucky enough to be tutored in tonal oil painting for seven years by the late Graham Moore. Malcolm credits Graham's wisdom and enthusiasm for teaching him how to look at, and visually understand, the world around him with whatever success he has achieved as a watercolorist.

Gradually, the passion to paint took over Malcolm's life, and in 1995, at the ripe old age of 49, he resigned from his job of 30-something years to become a full-time artist. With their children just beginning secondary school, it was a courageous decision by his wife Dorothy to allow him to do it.

A decision he says he does not regret.